T0353308

Live Theatre & The Empty Space present

Motherland

By Steve Gilroy

First performed at Live Theatre,
Newcastle-upon-Tyne 29 November 2007

Foreword

When news of a soldier's death is reported on television it is sometimes followed by a mother speaking of her child's bravery and her pride in them. With our country fighting two wars with limited public support, how are the friends and families of those serving being affected? What is it like to know your child is risking their life for a cause that many do not believe in? What is it like to lose your child in a war that many think is predicated on a lie? The starting point for the making of *Motherland* was an attempt to address these questions.

Between September and November 2007 over twenty women from the North East of England were interviewed. These included mothers, stepmothers, sisters, wives and girlfriends of service men and women who had served or were currently serving in Iraq and Afghanistan. Some had their loved ones home safe and sound, some faced the daily fear; the parent's worst nightmare and for some that nightmare had come true. The more women I met and the more testimonies I witnessed, the more I realised that this play would not just be about war and the tragedy of loss. *Motherland* situates the ordinary next to the extraordinary and presents a range of characters, relationships and stories of significant complexity; it is also testimony to the strength of women and the enduring love of mothers.

Motherland is not a mouth piece for any campaign, but is in part a critical look at recent and current conflicts and their impact on communities. It should also be remembered that although *Motherland* is constructed from testimony it is essentially a dramatic work; a play, crafted and rehearsed. This text is a mere snapshot; the 'actual' stories of those involved continue to unfold.

Steve Gilroy

Motherland

Ordinary lives, extraordinary stories
By Steve Gilroy

Cast

Rachel Adamson	Isabel / Janice / Gemma
Charlie Binns	Elizabeth / Carol / Nikki / Maria
Eleanor Clarke	Suzie / Elsie / Joanne #2 / Sarah / Maggie
Helen Embleton	Deborah / Joanne #1 / Jane / Pat

Creative & Production

Steve Gilroy	Writer & Director
Gary McCann	Set Designer
Drummond Orr	Production Manager / Lighting Designer
Martin Hodgson	Sound Designer
Richard Dawson	Composer
Taryn Edmonds	AV Designer
Lou Duffy	Costume Designer
Kate Craddock	Movement Coach
Simon Henderson	Stage Manager
Rachel Reddihough	Deputy Stage Manager

LOTTERY FUNDED

City Council

northern rock
foundation

Project Part-Financed
by the European Union

European Regional
Development Fund

Cast

Rachel Adamson – Isabel / Janice / Gemma

Rachel graduated from the Northumbria Live Academy with a Masters in Theatre and Performance Practice. Theatre credits include: *Jump!* (Live Theatre, Rehearsed Reading), *Motherland* (Live Theatre/Edinburgh Fringe – Winner of *The Stage* Best Ensemble for Excellence in Acting), *Iron* (Northern Stage/National Student Drama Festival). Radio credits include: *Belsay Poem* (Picture House Exhibition). Television and Film credits include: *Heroes from Home* (Tyne Tees).

Charlie Binns – Elizabeth / Carol / Nikki / Maria

Charlie graduated from the Northumbria Live Academy with a Masters in Theatre and Performance Practice. Theatre credits include: *Islanders* (Live Theatre, Rehearsed Reading), *Motherland* (Live Theatre/Edinburgh Fringe – Winner of *The Stage* Best Ensemble for Excellence in Acting), *Bit of Respect* (Operating Theatre), *Iron* (Northern Stage/National Student Drama Festival), *The Importance of Being Earnest* (Antic Mind/Palketto Stage). Television and Film credits include: *Return of Tracy Beaker* (BBC), *Skeletons* (Forward Films), *Edit* (Shameless Films).

Eleanor Clarke – Suzie / Elsie / Joanne #2 / Sarah / Maggie

After gaining her LAMDA Acting Diploma, Eleanor graduated from Northumbria University in 2005 with an honours degree in Drama. Theatre credits include: *Motherland* (Live Theatre/Edinburgh Fringe – Winner of *The Stage* Best Ensemble for Excellence in Acting), *Bessie Watty*, *The Corn Is Green*, *Arabian Nights*, *Northanger Abbey*, and *Iron* (Northern Stage/National Student Drama Festival). She has taught dance and drama in several theatre schools in the region as well as for Kneehigh Theatre Company and has done voice over work for the Tyne Forum.

Helen Embleton – Deborah / Joanne #1/ Jane / Pat

Helen graduated from Birmingham School of Acting with a first class honours degree in Acting. Theatre credits include: *The Tempest* (Customs House), *Stand N Tan* (Open Clasp), *Different Daisies* (Live Theatre), *Motherland* (Live Theatre/Edinburgh Fringe – Winner of *The Stage* Best Ensemble and nominated for the Stage Best Actress), *Pub Quiz* (New Writing North), *Transgenia, Adventures in Wonderland* (Operating Theatre) and *Iron* (Northern Stage/National Student Drama Festival – Spotlight Award for Best Actress). Radio credits include: *Belsay Poem* (Picture House Exhibition) and *Saturday Matinee* (Tyneside Cinema).

Creative & Production

Steve Gilroy – Writer & Director

For Live Theatre: *Motherland*, *Me & Cilla* and *Iron* (Live Theatre at Northern Stage*)*, *Home by Now* (at Baltic), *Top Girls*. Other theatre credits includes: *Ballroom Cougars* (Live Theatre/New Writing North), *The Censor* (Studio Theatre, Cape Town S.A.), *Terrorism* (Oval House), *Naturalised*, *In the Family*, *Mr Sinclair's Teeth*, *Trace* (Royal Court), *Ultra Violet* (Royal Court/Duke of York's Theatre), *Act Without Words* (Embassy Theatre, Central School of Speech and Drama), *TV Tots Meet Bomb Boy* (London New Plays Festival, Riverside Studios), *Life On*

Mars (Riverside Studios), *Coming Out* (Liverpool Everyman).

As writer/director credits include: *Hand Me Down* (Pleasance Edinburgh, Live Theatre Sibu International Theatre Festival), *Motherland* (Live Theatre/Edinburgh Festival), *Now We're Ten* (Yvonne Arnaud Theatre). Awards: Fringe First, *The Stage* Best Ensemble Award, The Jack Tinker Spirit of The Fringe Award (*Motherland*), Nomination Fringe First (*Hand Me Down*).

Gary McCann – Set Designer

Gary McCann trained at Nottingham Trent University. For Live Theatre: *Me & Cilla*, *The Pitmen Painters* (Live Theatre, National Theatre, Volkstheater Vienna, UK tour autumn 2009), *Motherland*. Other theatre credits include: *Guys and Dolls* (Theatre Bielefeld, Germany), *Fidelio*, (Garsington Opera), *There's Something About Simmy* (Theatre Royal Stratford East, national tour), *Home by Now* (at Baltic), *Thieves' Carnival*, *Broken Glass*, *Arabian Nights* (Watermill Theatre, Newbury) *Hurricane* (Arts Theatre London, 59th St Theatre New York), *Protestants* (Soho Theatre), *The Half*, *The Early Bird* (Ransom Productions, Irish tours) *Much Ado About Nothing*, *The Glass Menagerie*, *The Man of Mode*, *Twelfth Night*, *Tearing the Loom*, *The Visit*, *Iphigeneia* (Lyric Theatre, Belfast), *Song of the Western Men*, *Shang-a-lang* (Chichester Festival Theatre). Designs for opera include *L'Elisir*, *The Magic Flute*, *The Pearl Fishers*, *La Boheme*, *The Barber of Seville*, *La Fille du Régiment* (Swansea City Opera), and the new opera *Promised Land* for Canterbury Festival. Gary is Lecturer in Design with the Drama department at the University of Kent. His designs were recently on display at the V&A museum as part of the Collaborators exhibition. He is currently designing *La Voix Humaine* and *L'Heure Espagnole* for the Nationale Reisopera in the Netherlands, Norma, Moldavia and Netherlands tour, and Grimm Tales for the Library Theatre, Manchester.

Drummond Orr – Production Manager / Lighting Designer

For Live Theatre: *You Really Couldn't Make It Up*, *You Couldn't Make It Up*, *Geoff Dead: Disco For Sale*, *Me & Cilla*, *The Pitmen Painters*, *Motherland*, *Cooking with Elvis*, *Bones*, *Cock of the North*, *Toast*, *Our Kind of Fun*, *The Bodies*, *Briefs*, *The Lovers*, *Top Girls*, *A Nightingale Sang in Eldon Square*, *Home by Now* and *Iron*. He has also worked for Northern Youth Dance Company, Northern Stage, Théâtre San Frontières, Monster Productions, BalletLORENT and Vincent Dance. Dummond recently worked on the transfer of *The Pitmen Painters* to the National Theatre.

Martin Hodgson – Sound Designer

For Live Theatre: *Geoff Dead: Disco for Sale*, *Me & Cilla*, *The Pitmen Painters*, *Smack Family Robinson*, *Toast*, *A Nightingale Sang in Eldon Square, The Lovers* and *Keepers of the Flame* and many more. Sound design credits for Northern Stage include: *1984* and *A Clockwork Orange* (Northern Stage).

Richard Dawson – Composer

Richard Dawson lives and works in Newcastle upon Tyne. He has released a number of albums under his own name, including 2005's acclaimed …*Sings Songs and Plays Guitar*, the sound–collage *Terdis*

Merula: Bird of Death!, an EP of experimental folk called *Delight Is Right*, and most recently *Dawson May Jazzfinger Clay*, a split-album with underground legends Nev Clay and Jazzfinger. Richard also creates long-form electronic psychedelic music under the name Eyeballs, and has released a number of albums under this name, including *Sea Of William Henry Smyth*, *Seal-Skin Satellite*, *Europa* and *The Roof Of The World*, with a further five due for release before the end of the year. He has toured nationally and performed with the likes of Giant Sand, Jack Rose, Martin Stephenson and The Handsome Family. He's made guest-appearances on albums by Beccy Owen and Nev Clay, and was last seen performing on BBC2's *Culture Show*. Richard is also a regular columnist for North-East music magazine *Narc*.

Taryn Edmonds – AV Designer

Taryn studied at Newcastle University, gaining a degree in Fine Art. She currently works as a freelance visual artist, specialising in moving image, installation and live art, and has exhibited her work both regionally and nationally. Taryn is interested in the potential of cross-practice collaboration and has extensive knowledge of working with other disciplines such as performance and dance, creating work both site-specifically as well as within more traditional spaces.

Lou Duffy – Costume Designer

Lou has worked as costume designer and wardrobe supervisor on productions at Live Theatre as well as working with other theatre and dance companies across the region.

Kate Craddock – Movement Coach

Kate Craddock is a performer, performance maker and university lecturer. Credits as creator/performer include: *Hand-me-down* (Pleasance Edinburgh, Live Theatre, Sibiu International Theatre Festival). Performances as co-artistic director/performer Mouth To Mouth|International Performance Collective include: *A River Ran Through Us* (LIFT), *No Fixed Abode* (BAC), *Contamination/Masque of the Red Death* (BAC/Punchdrunk), *Under the Stairs* (Northern Stage), *By your side* (Dublin Fringe Festival). Other theatre credits as performer include: *A Manifesto for a New City* (Northern Stage).

Simon Henderson – Stage Manager

Originally from Wimbledon Simon moved to the North East and studied an HND in Theatre and Media Production at Newcastle College. Since graduating 1995 he has worked as Stage Manager/Production Manager for a number of theatre companies in the North East, including Mad Alice Theatre Company, Live Theatre and Northern Stage. Simon has also toured extensively in Britain and abroad.

Rachel Reddihough – Deputy Stage Manager

Rachel graduated from Rose Bruford College in 2007 with an honours degree in Lighting Design. Since then she has worked across the country on many shows, from serious drama to more lighthearted productions, as Lighting Designer / Stage Manager. Rachel was Stage Manager on *The Garden of Dreams* (Monster Productions / Live Theatre) which toured the UK and Ireland.

Live Theatre: Newcastle upon Tyne

Live Theatre was founded in Tyneside in 1973 by, amongst others, Tim Healy. It began by touring into the community and presenting plays to people who didn't normally attend the theatre.

The company's mission has been inspired by a quest to understand and interpret the social history and identity of the region it serves and examine the issues and events that affect its people. This has created a profound well of source material and an astonishing array of stories; often personal and set against large historical, social and political backdrops that despite their specific locality are essentially universal in their significance. *The Pitmen Painters* by Lee Hall, winner of the 2008 Evening Standard Best Play Award, is a prime example of the success of this policy. The play is to begin a nine-week UK tour in autumn 2009.

Crucially, Live Theatre has always maintained a belief in talent and sought to provide a platform for writers, actors and directors to develop and flourish and has always attempted to place the audience and their concerns at the centre of its creative programme.

Located in a beautifully restored and refurbished complex of five Grade II listed buildings on Newcastle's quayside, Live Theatre is home to a unique cabaret-style theatre where members of the audience are never far from the action on stage.

If you are in Newcastle please call in and see us.

Live Theatre, Broad Chare, Quayside
Newcastle upon Tyne NE1 3DQ

Admin: (0191) 261 2694
Box office: (0191) 232 1232
Fax: (0191) 232 2224
Email: info@live.org.uk
www.live.org.uk

Supported by
ARTS COUNCIL ENGLAND

Newcastle
City Council

The Empty Space

The Empty Space was established in 2007 as a theatre development agency, supporting emerging artists and new work in the North East of England. The company provides advice, training and creative and practical help to meet the widest possible range of practitioner needs and to strengthen a developing community of artists. Arising from the extensive links the directors have built with promoters and producers across the country, The Empty Space has been able to bring internationally acclaimed artists into the North East for the first time to provide training and workshops for practitioners there – including the last development stage of Ridiculusmus' *Tough Time Nice Time* before its premiere at the Barbican and a week long residency from Kazuko Hohki – as well as hosting the first ever Devoted & Disgruntled theatre conference to take place outside London.

As producer, The Empty Space works with a range of North East artists whose work challenges the boundaries of traditional theatre. It premiered three pieces at the Edinburgh Festival Fringe in 2008 and, having achieved a number of sell out performances, four and five star reviews and two award nominations, the company is now touring these shows. *Heartbreak Soup* will be seen across Britain from autumn 2009; *Hand-me-Down* has just returned from the Sibiu International Festival and a spring tour is planned for 2010; and *The Gymnast* has been selected for the Singapore Fringe in January 2010.

After only two years, the company is already regarded as 'a fantastic asset to the north east theatrical landscape'.

Supported by
ARTS COUNCIL ENGLAND

northern rock foundation

Project Part-Financed by the European Union

European Regional Development Fund

Thanks to all the women who contributed their stories.

For Gay, Maureen, Traci and Kate.

MOTHERLAND

First published in 2009 by Oberon Books Ltd
521 Caledonian Road, London N7 9RH
Tel: 020 7607 3637 / Fax: 020 7607 3629
e-mail: info@oberonbooks.com
www.oberonbooks.com

A catalogue record for this book is available from the British
Library.

ISBN: 978-1-84002-948-2

Cover photograph by Keith Pattinson

Characters

ISABEL (A woman in her sixties)
From County Durham

SUSIE (A woman in her early twenties)
From Newcastle-upon-Tyne

DEBORAH (Daughter of Elizabeth, in her early
twenties) From Northumberland

ELIZABETH (Mother of Deborah, in her late
fifties) From Northumberland

ELSIE (A woman in her sixties)
From South Shields

JANICE (A woman in her forties)
From Sunderland

JOANNE 1 (A friend of Joanne 2, in her early
thirties) From County Durham

JOANNE 2 (A friend of Joanne 1, in her early
thirties) From County Durham

JANE (A woman in her twenties)
From Kent

SARAH (A woman in her twenties)
From Surrey

GEMMA (A woman in her early thirties)
From Hartlepool

CAROL (A woman in her late thirties)
From Lancashire

NIKKI (A seventeen year-old girl)
From Sunderland

MAGGIE (A woman in her early forties)
From Newcastle-upon-Tyne

PAT (Mother of Maria, in her sixties)
From South Shields

MARIA (Daughter of Pat, in her early thirties)
From Essex

Motherland is the result of the collection, collation and editing of a series of interviews conducted by the writer and members of the company between September and November 2007. The text is entirely made up of words spoken by the interviewees. Some names have been changed at the request of the interviewees.

The interviews were all conducted in, Newcastle-upon-Tyne, Sunderland, South Shields, Northumberland and County Durham.

The Set comprises piles of used ammunition boxes.

All sixteen characters are played by members of the company. *Motherland* was originally produced with four actors playing multiple roles, however up to sixteen may be used.

NOTES:

Words in square brackets [] are not spoken, but are for clarification of meaning.

A stroke (/) indicates the point of interruption.

'TOGETHER:' indicates where two characters speak simultaneously.

A character's line placed within the text of another indicates that the latter continues uninterrupted, therefore the characters are speaking simultaneously. For example:

DEBORAH: We had the same friends, my friends were his friends. [ELIZABETH: Yeah, you both had the same friends.] If he was drunk somebody would come and find me in the pub somewhere to come and take him home.

Act One

Blackout. The sound of a military helicopter encircling. Cross-fade to the stirring of 100 cups of tea. Lights up. The actors sit facing the audience holding cups and saucers; stirring. Simultaneously they tap teaspoons on the edges of their cups and place in the saucers. Two of the actors are picked out by light as the title 'ISABEL' is projected.

Throughout the scene ISABEL remains seated and poised while SUSIE roams. SUSIE is aware of ISABEL and listens to her. ISABEL is unaware of SUSIE. Unless otherwise indicated both characters address the audience throughout the scene. ISABEL occasionally addresses her husband, Alan. Alan is not seen.

ISABEL: She is a formidable lady. She always has been. (*Pause.*) Erm. A lady that was in charge of the household. She worked hard, in the house, being a mother. And a wife of course, because me dad worked at the mine, and… I can remember where we lived having no running water, no inside toilets.

She still doesn't like the fact that the mine is no longer there, she thinks it looks terrible without the mine, the pit…erm she was very upset when they closed it, she still is a worker, she's eighty-nine, and she still believes every woman should sort of, look after their husband and look after their family, you know?

The title 'SUSIE' is projected.

SUSIE: Our Mams have always…known each other cos they're both dinner ladies…erm, and they work at the same school so we'd always known each other from when we were quite little. We used to like go round and play.

It was canny really cos I haven't got any brothers or sisters or anything, so I suppose she was…the nearest thing I had

to a sister at the time. Erm, but she was a year older than me and I mean…a year's nowt now, but when we were little I thought she was dead cool. She started school before I did, 'n like, she had a boyfriend before I had one and… well not that I ever had a boyfriend like, but y'nah. I just thought that…y'know? I looked up to her like a big sister.

ISABEL: I actually met him on the bus coming home from the rink, and that was it, we just started…he took me home and we just started going out together. And we were courting for a year and a half, engaged for a year…and three months. And we've been married for (*Beat.*) forty-two years. (*Hears a sound.*) You'll have to excuse me one minute, the 'Ringtons' man's coming.

SUSIE: And there was one night we'd gotten, gotten a bit, a bit sloshed to be honest…erm…and we just… I don't even remember how it happened actually. To be. Quite, honest I'm, sure she'll kill us for that, don't tell her. Er, I just remember that we were kissing and, everyone was cheering and stuff, you know like they do. (*She cheers.*) I was dead embarrassed, eee I'm embarrassed now talking about it.

Erm, but yeah, so we started kissing and then we just kinda…kissed some more times…and then…and then, we only kissed each other and then we held hands in public and stuff.

ISABEL: She was a very…as I said a formidable lady, very strict, very, very strict. When we were engaged to be married, Alan and I, I still had to be in by nine o'clock. And what she said, that was law!

I often think that if we'd been Eskimos I would have been put out on the snow. You know? Girl babies are no good, you know?

She was quite harsh and I was frightened of her. I'm not now obviously. But it's not until you say that you're in your

sixties and you should be able to do as you like; that you have own opinions. See I was never allowed opinions.

SUSIE: I think for a while we forgot to tell them: our Mams. But erm, we were just talking about the fact that we were, were moving in and stuff and they were saying: 'Do y'not think that'll be weird living together do y'not think it'll be hard to share a, share a space?' and Claire had said: 'Well other couples share a space.' And there was just this silence.

She was taking her Mam back. 'n my Mam? I went back into the room and she was, just silent. She just didn't say a thing at all. We were just sitting watching the telly and she hadn't said anything about it and all of a sudden she just said: 'Is it my fault?' And I was thinking she was talking about the telly, and I was like: 'Mam what yuh on about man? Is it, is it your fault the telly's on. What?' She was like: 'Is it my fault you're a lesbian. Is it because like, you know, did we do this?'

ISABEL: (*Laughs.*) I used to be on the amateurs, years ago (*Blows tongue.*) that many years ago. And I used to dance. And it was the night. It was the Saturday night of the show and he was meeting me after the show waiting for me to come out, you know? After you'd got ready and what have you. Handed your costumes and that back, it being the Saturday night. And I looked around for Alan. And here he is you know sorta staggering up the road. He says: 'How about we get married?' So I said: 'OK. Right.'

And that was how he proposed; he was stoned out of his mind. (*Laughs.*)

(*To him.*) Are you listening? They're asking how you proposed. (*Laughs.*) He can't remember. He says he can't remember getting married. He denies any knowledge of it, you know? And he says it's too late now nobody would have us.

SUSIE: But I mean, they've been great, 'n her Mam especially. While she's been in Iraq I've been like, we've been going shopping and stuff together…

ISABEL: Two sons; Mark was thirty-seven in March, David'll be thirty-five in erm, October.

Erm when Mark and David were growing up, when their dad was thirty-four it would've made Mark…(*Asks Alan.*) How old was Mark and David? (*Short pause.*) When you had your accident? (*Short pause.*) Uh-huh Mark was about nine, David would be about six and a half er… Alan had an accident at work which left him severely disabled and he's never been able to walk since.

SUSIE: …'n we go for coffee and stuff and just like…like the other day she came round, she brought her, she brought her baby photos round.

ISABEL: I've got photographs of where they were both dressed as cavalrymen. Then Mark was a Martian. No. Not a Martian erm…what do they call them? a space…? Erm, (*Finds it.*) an astronaut! Had the big plastic dome and everything, David was an Indian chief I think at the time, errm they liked dressing up, David always liked dressing up. David joined the RAF at seventeen, Mark was what about…nineteen?

Well it was my daughter-in-law said, she said: 'Have you realised what's happening?' And I said: 'Well I don't know what you mean'. She says: 'Well both of your sons are going to be away at…they're going to be together. Sort of anything and your whole family could be wiped out in one second, you know?'

SUSIE: She'd always said she'd wanted to be in the army, but erm…It's just like, I mean I always said I wanted to be a vet but, I'm…I'm not a vet. It's just like, I thought it was just one of them things, where you know like: 'Oh aye when I grow up I'm gonna be in the army' and then,

before you realise it, you're like grown up and that. I'm not a vet but she did join the army.

ISABEL: I mean I never looked at anybody on that television and thought: 'I hate you because my two sons are in your country and you're trying to kill them', you know? Never thought that at all.

SUSIE: When she left she was crying and stuff and she'd said: 'Will you look after Spot?' And I was like: 'What the hell are you on about? Spot?' And then I remembered what she meant. She really wanted to take him with her but she wasn't allowed, so, she left him for me. She buys 'em…you know the Bear Factory? He's not from there but the clothes from there fit him. So he's got like…he's got antlers and a red nose for Christmas and stuff, and he's got like, a birthday jumper.

I make fun of her for keeping him but I bought him a little army outfit when she went and he's got some dog tags with Spot written on. But I had to engrave it myself with a compass cos I wasn't taking it to a bloody jewellers to get it engraved for a flippin' teddy.

ISABEL: I mean it's, it's, it's your own flesh and blood and I imagine that they just have exactly the same feelings. Both Mark and David said they've never seen anywhere so desolate err a place to live, what those people have actually lived through.

SUSIE: I mean maybe it's just cos I don't really pay attention to stuff like that but, I don't think they're sure what they're fighting for themselves anymore.

ISABEL: There is a chance that David'll have to go back. Erm…and I really wouldn't like it.

SUSIE: And it was only, it was only, when like it got right into the war when I started to think how danger…dangerous it was, and I was like well…you know: 'Are you sure you wanna do this?'

ISABEL: Well. I'm the kind of Mother that likes everything in order, tidy, neat, precise, dusted, polished. Everything just so.

Maybe I should have said: 'I *was* the kind of mother', '*was*', '*was*'. Lately, erm, well three years ago our lives changed again when all the cancer came back. Now, I'm the kind of mother who believes every Christmas we have is the last Christmas, so I make it so so special. And it's nice. And you just laugh. And they wait for the time I have my second glass of wine, and err I can't, can't drink more than one glass and I'm always: 'Oh why not we'll have another glass', and me Mam's there so disapproving. So disapproving.

I've got to go back into hospital again next Friday erm see what they can find. I think…it would be worse if they had to go away again. The situation it's left us very, very vulnerable you know? Erm because if I die, Alan'd have to go into a home. And he wouldn't live with the boys because he wouldn't think it would be fair. You know to sort of put on to them.

SUSIE: It's not our country so…we've done what we needed to do, why don't we just like, I think they should just pull them out now, and bring them home. But, I mean, maybe that's just my opinion cos, I want Claire to come home. I just want her to come back.

Phone rings.

ISABEL: (*To Alan.*) If that's me mam tell her I'll ring her back later. (*To audience.*) She's already been on the phone. She phones twice a day. (*It is her Mam.*) Ahh there'll be questions asked, (*To Alan.*) was she alright? (*To audience.*) She'll be sat next to the phone now thinking: 'Well what's she doing? She's doing something she's not supposed to be doing? Well who's she got there?' Oh it'll be honestly you've no idea! It's not that long ago she told Alan I should be taken down a peg or two, that I'm too outspoken, and he should knock me back.

She still thinks she reigns. She's eighty-nine.

Music. SUSIE removes a couple of items of costume and places in ISABEL's out held apron. The remaining two actors are assisted with a brief costume change by ISABEL This is all done gently and with care. ISABEL sits upstage folding the items given her by the others. DEBORAH sits and ELIZABETH stands next to her. ELSIE sits. Music fades.

SCENE 2

Titles: 'DEBORAH, ELIZABETH'.

During the scene DEBORAH and ELIZABETH address an unseen interviewer. The interviewer changes position so each time we return to them they are focused on a different spot. ELSIE talks directly to the audience. ELSIE cannot see DEBORAH and ELIZABETH unless indicated and they cannot see her.

DEBORAH: I don't know… (*Looks at Mother.*) Mum? Up until, probably eleven, twelve, twelve, thirteen we got on really well and then between thirteen, fourteen, fifteen, sixteen, until he reached fifteen, sixteen we hated each other.

ELIZABETH: (*Giggles.*) I don't know any of this.

DEBORAH: And it was quite hard. Once we started going out drinking sixteen, seventeen-ish we got on really well because we were really close in age, he was only a year behind me in school so his friends were my friends, [ELIZABETH: Yeah, you both had the same friends.] we had the same friends, my friends were his friends. If he was drunk somebody would come and find me in the pub somewhere to come and take him home.

ELIZABETH: This was a particular night that we all remember very well. Dad he's / drunk and (*Laughs.*)…

DEBORAH: Aye he was just really, really smashed one night, I think he drank one of those third-bottles of vodka or something and he was on a fire escape in a pub on the Quayside and I'd spent half my night queuing to go to the

23

toilet [ELIZABETH: Ladies toilet.] I was right at the front of the queue and somebody came in and said: 'Is Anthony's sister in here? He needs her', so I just had to go and he just couldn't see, couldn't talk, he just went: 'I need to go home', so I had to ring dad... [ELIZABETH: 'Dad he's paralytic come and get us'.] ...come and put him in the car. And that...that was his night ruined.

ELIZABETH: Oh I got the phone call, you know I...but they were both very sensible, they knew, you know to...to ring home and we laughed bless her, she was crossing her legs and she erm, Andrew said: 'I'll go and get them' and he said: 'Don't be cross', and I said: 'No I'm not cross'. I said: 'Let this be a lesson'. And he never did it again, he never did it again. He was so ill. But thank God she was there.

DEBORAH: So I suppose as tiny kids we always got on [ELIZABETH: You did, yeah.] and as bigger kids we always got on and we still get on. [ELIZABETH: Yeah they're very, they're pretty close.] I remember being with him a lot of the time.

ELIZABETH: Very much so actually because she looked after him. I was actually quite ill at the time and she actually looked after him, (*To DEBORAH.*) cos you did, and actually I've got a vision of the two of them, because she used to love dressing up, right. My high heels were her favourite. She would go into the wardrobe and get out the high heels like kids do, but so would Anthony you see, because he did everything she did and I can... (*She laughs.*) I've got a vision of him standing in his high heels with his little handbag and he had a necklace round his neck, and you know this was Anthony, he just did everything she did, he just copied her and I said well let him do it while he's little this is fine, hopefully he'll grow out of it and didn't worry about it. The two of them were very close when they were little, very close. (*To DEBORAH.*) Looked after him.

DEBORAH: I still would.

Titles: 'ELSIE'.

24

ELSIE: I was born in South Shields. Erm… Six brothers. Two sisters. Lived right near the beach. Majority of family are in uniform. Police. Prison Service. Army. Erm. Met my first husband. Didn't work out. Met Colin. Erm, I've got five children. Four boys and one girl. All been in the Forces. Er, haven't had a bad life really. Pretty good.

ELIZABETH: When he was at school erm, the RAF used to visit the school so from about being about 13, so we're coming now out of his, into his young teens, and erm, we'd talk about the RAF. He kept saying he wanted to join the RAF/, that's what he wanted to do.

DEBORAH: That's all he's ever wanted to do, I don't think he's ever talked about anything / else

ELIZABETH: Yeah, never ever talked about anything else. He was single-minded, very much so, just as she was from wanting to be a nurse, we've got photographs of her as a little one with her nurses uniform on and it's never changed. They've / both…

DEBORAH: You've got that photo of him with this inflatable Boeing 747 / or something.

ELIZABETH: Yes, never left them. Never left him.

ELSIE: Always very confident. Er, I was a dinner lady at the time at the school where she started. Walked past the classroom and she was standing in front of the class and I thought: 'Oh, what's she done wrong?' The teacher came down the corridor and I said: 'What's happened? What's Sharon standing at the front for?' (*In a 'posh' voice.*) 'Oh, my dear', she said: 'She's got a very calming influence on the other children so I put her there when I go out of the classroom.' She were only about six year-old.

ELIZABETH: Ah yes…

DEBORAH: He had / a blue ted

ELIZABETH: A little blue ted and that was one. / Little Ted went everywhere with him.

DEBORAH: I remember he lost Blue Ted / though and we had to buy him another one.

ELIZABETH: Yeah he lost Blue Ted and we had to go and buy him another one, he was distraught when he lost Blue Ted.

ELSIE: She had a white pussycat. Em, it was a head, a body and a tail.

ELIZABETH: Tiny, it was about, it would be about...

DEBORAH: Six inches.

ELIZABETH: Six inches.

ELSIE: And that was it. It was about, it was about like that. (*Indicates with her hands.*) But it just, it had a tail, two back legs, it didn't have any front paws and it had a head. And that was it.

DEBORAH: White tummy.

ELIZABETH: And / little...

DEBORAH: White / paws.

ELIZABETH: And pale blue, very pale blue [Deborah: Like baby blue] infact We've still got Second Blue Ted upstairs in a box.

DEBORAH: It would be if, if you imagined it flat, / not like a rotund a bear, it was like a flat bear.

ELIZABETH: Yeah it was flat. I've got Second Blue Ted still. I kept it.

ELSIE: And she carted it everywhere. Bed, everywhere she went.

ELIZABETH: As soon as he came out of university, he went to Cramwell and trained as an officer and he was the first to qualify in 2000, he was the first passing out parade in 2000.

ELSIE: They told her she was officer material, that she could have gone to Sandhurst to train. And then two female officers came to see us and said that they thought it would be best because of her background, because we weren't moneyed people, I presumed, erm for her to join the Forces by all means, but start at the bottom and work her way up.

DEBORAH: At one point in time I had, my boyfriend was out there, my brother was out there and his fiancée was out there. So I had three of them away in different places. Alice was in Iraq, Anthony was in Afghanistan and John was in Bosnia. All in the military [ELIZABETH: All in the military.] All at the same time and all deployed at the same time, and at that point in time I didn't know whether I was coming or going, because I didn't know who to worry about the most cos I didn't know who was in the / most danger.

ELIZABETH: That wasn't nice, it wasn't nice.

DEBORAH: So, but I think with Anthony, specifically with Anthony it was probably just this last tour and I think the specific memory that brings it back to me is when I was in New Zealand and I spoke to Alice, Anthony's wife, on the phone and she said: 'Anthony really wants you to come home before he goes away, is there any chance you could come home?' And that…there was no way I could have done it, I'd have had to cancel the remainder of the trip.

I thought: 'Why's he asking me to come home you know?' He knows he's going somewhere that's really horrific and erm that's the one thing I do remember. He would… I don't think he would ever have said it to me but it was Alice you know, his wife said, said that so…

I was with a partner for the whole year we were away, so I wasn't on my own.

ELIZABETH: Emotionally you were on your own.

DEBORAH: Well yeah because it's a personal…dealing with the homesickness, dealing with being away from friends and family, being away, especially when you've got a family member who then is told he's going to Iraq while you're away enjoying yourself [ELIZABETH: Sorry sweetheart.] there's no way I'd have travelled with anyone else and I don't think I'd have actually gone on my own, I think you just, you do become, you get to the point where you trust your life with somebody and you wouldn't want…you know I'm quite happy with that and I would still travel tomorrow with him kind of thing because you do build up that trust.

Pause.

ELIZABETH: Well they, they aren't erm. They'd fallen out erm, they were going away as / friends.

DEBORAH: This isn't about me mum.

ELIZABETH: No, it was just the emotions, sorry it was just the emotions of it sweetheart that's all, / that's all.

DEBORAH: Yeah well my personal life has got nothing to do with this, what I went through over there was what I went through. It doesn't matter where / I was or who I was with I would have gone through it.

ELIZABETH: It made the emotions worse for you I think that's, I think that's the point I was trying to make

DEBORAH: Yeah I was having a shit / time.

ELIZABETH: It was making the emotions worse for you.

ELSIE: So she did it. I mean, she used to run against the men and all this sort of thing. And I used to think: 'You can do it, you can do it' and she – very rarely did she come below third. She was so determined she would keep up with the men. Em, and she did this Aircraft Technician Course. She was the second person in the country to have done it, this technician course. And then, em, she met a lad, and they

28

were due to be married and four days before the wedding he got killed in a car crash. It was not very nice.

Oh she couldn't settle – not with her job – with blokes, and that. But then she met this other nice lad and he got killed in a motorbike accident in Germany. So she thought she was jinxed.

But like I say, she was, that part of her life was very sad. But she was, she was OK. Although it still hung about her, she was doing alright.

ELIZABETH: Then the only time I think I did mention to her that he was having a really bad…well there was twice. There was once when a friend of his was killed when he was there. That was a bad day for him. And Christmas day. Christmas day of this last year was the only time I sat and cried after the phone call from him because I knew she was on a beach / in…

DEBORAH: I wasn't exactly, but yeah I was in / Belize.

ELIZABETH: You were in Belize on a beach having a Christmas meal, it was all organised, she told us what was going to happen, there was two of them in charge of the cheese, two of them in charge of this, whatever, you were having a nice time.

DEBORAH: Well I wasn't having a nice time because Anthony was having a shit time.

ELIZABETH: Well we thought you were alright, we knew you were / alright.

DEBORAH: I was fine safety wise.

ELIZABETH: Yeah but he wasn't, he was having a very bad day, very bad day, and when I put down the phone to him those were the only tears in the six years that he's been away that I sat and cried. That wasn't nice, wasn't nice.

What I was going to say is the two of them have always been brought up to be kind to people, you know, turn the

other cheek [DEBORAH: Yeah it's not...] that, that was how they were brought up, always be kind, always turn the other cheek you know? Don't look for trouble you know, walk away. A little bit of kindness goes an awful long way. And certainly Anthony's experience... The story he tells of when he was out in Bosnia erm, there was a little old lady that he used to meet and talk to that lived on the street, who'd lost her house, her house had been bombed, she'd lost her family and didn't know where they were, and she sat...she liked Anthony, he used to sit and try and talk to her. She didn't obviously, couldn't speak very good English, erm she'd looked into his eyes this day and said: 'You, you...' in her own words: 'You a kind man' and sat and knit him some socks, like little booties. They're not really socks they're like a child's booties, and she spent about four weeks sitting, knitting these out in the open, because she only had a little tarpaulin shelter and she'd built a little fire out of stones that she could boil a kettle on and when he'd gone to see her this day and she had this present for him he says he just sat and cried. I mean she had nothing, she had absolutely nothing but somehow she'd managed to get the wool and knit these little, booties for him. Act of kindness. Act of kindness. I think they did manage to find erm where some of the bodies, they were looking for bodies out in Bosnia, where all these people had been buried.

ELSIE: With, em, Sharon's job and the job the lads and lasses are doing, they go to gather intelligence, you know. They sort of snoop about the place and have to report different things in so it depends on where the problems are.

But Iraq she had to wear a uniform, you see, cos it was classed as a war zone.

So, first time for five years she'd worn a uniform.

DEBORAH: I think when he's come home he's erm, you know, his, his opinion of: 'I won't, you know never do harm to anyone ever again', / kind of thing

ELIZABETH: Well bless him I don't think he did

DEBORAH: No, no / but he…

ELIZABETH: Cos he didn't want to, that was part of his conflict.

DEBORAH: But I think he's, he's brought it right back down to the whole basic level of, of you know; it doesn't matter who it is, if it's somebody who stops you in the street and says: 'Have you got 20p for a cup of coffee', give them it.

I think he's just seen so much evil, so much nastiness, so much terror, just physically being frightened himself it's just not worth…

ELSIE: She was scared. First time she's ever said that. She didn't want to go. Blimey, she'd only been in Cyprus a couple of months of a two-year posting.

That's the first time she's ever told me she was scared about something.

ELIZABETH: Yes, Anthony had this friend, God bless her, in South Shields, who lived in South Shields who was killed. He worked with her for a couple of years in England…err and she was killed in November last year. She was in Basra when he was in Baghdad when it happened. There was about four or five of them killed. She was in the army whereas he was in the RAF. She was an intelligence officer.

ELSIE: I think the worst thing was I'd finished work that morning. I've come home cos we were decorating in here and we'd started stripping the wallpaper off so all the furniture was in the middle of the room. And then we'd got the wallpaper off, got washed and changed, sat down to watch the television before we went to bed.

ELIZABETH: Wrong place wrong time. She was on a boat and the bomb went off on the bridge. I think that's what, I think that's what happened. That was a bad day for them, that was a bad day. Four or five Brits killed. That was a bad day.

ELSIE: The knock at the door. I thought. (*Tuts.*) Colin went down to the door and I just, I heard him saying: 'Mr Manning' and I'm sitting there going: 'Bloody gasman late on a Sunday night'. You know how those men keep knocking at your door? Erm, Colin called me so I got off the settee (*She rises.*) and I just got as far as here and I saw the bloke standing in the hallway and I just went: (*Points.*) 'I know what you've come for'. Just see, you can just tell. He was only a young lad as well. Awful job for him as well. But you just know. (*Short pause.*) And then, there's just numbness after that.

Em, well apparently, she went out on the Sunday and during that first week she'd been on the land, she'd been in the air, like the helicopters, and then she had to go on the boats. But they were moving camps cos she was em, in Basra Palace and they got moved up to somewhere else, but they went by patrol boat this day and there was three boats. The first one went under the pontoon bridge cos there was only one place they could get through. Erm, her boat started to go through and bang. Improvised bomb. Four of them died, three of them injured quite badly. (*Dogs begin to bark in the yards outside.*)

Cos if your kids get hurt, I mean, from an early age you're there for them and then something like this happens and you're not. And you can't get to them, you know. (*Dogs bark louder and ELSIE reacts.*) Shut up! Shut up! You get that all the time. And there's three over the back do it as well.

DEBORAH: The way other people run their countries has got nothing to do with us and I saw that in various other countries around the world but I just think it's an absolute disgrace that people think that they've got the right to charge into somebody else's country / and take over.

ELIZABETH: Iraq was a conundrum, it was a real, from my point of view, it was an absolute conundrum. Something needed to be done but I don't know what was, / you

know? What was the right thing? They needed help. Did they get the right help? / I don't think they did.

DEBORAH: But there's so many other countries that it's happening to and you don't hear about it because we don't have troops there and the whole side of why our troops are there, why our friends and family are over there is…you don't know and to be honest if you ask them they wouldn't know why they're sent there either. And I think the disillusionment in everything is showing its, its true worth because there's so many people resigning now, just coming out / and saying I'm not doing it.

ELIZABETH: They're coming out in their droves, coming out in their droves.

ELSIE: So. I think what we want to do is just let them all kill each other. Cos to be quite honest, my opinion and attitude's totally changed towards them. I was always: 'Oh we should be there helping them', but not now. I, um, got told off in a shop a few weeks ago because they were talking about terrorists and everything. I says: 'D'you know what?' I says: 'If there was an English bloke and one of them standing in the middle of the road and my car went out of control,' I says: 'where would I head it?' 'You can't say that.' I says: 'I can. They killed me daughter. I can say what I like. Put me in prison if they want, I don't care.' And that's the way I feel, cos I just think, they just, they're so arrogant. If we go to their country we have to do what they want. They come over here and we have to do what they want as well. You know, it's all wrong. What you want to call your play is 'Whose Country Is It Anyway?'

DEBORAH: Right, I'm away.

ELIZABETH: Ah she'll have to go.

DEBORAH: (*To the audience.*) Yeah I'll have to go, if you… (*Realises she's interrupted the interview.*) Is this alright just to chat like this? If you want more I can, I can come back, I can meet you again.

ELIZABETH: Now drive carefully for heaven's sake sweetheart. Take care.

DEBORAH: I will do, I will do. I'll speak to you later or I'll see you / tomorrow night.

ELIZABETH: OK treasure, take care darling.

As DEBORAH exits she pauses and watches ELSIE with concern.

ELSIE: Getting very bitter, you know. Angry.

That oh – I mean you ask me that again in another couple of months and I might feel differently but at the moment, I just, I feel I don't care, I just… If our, if our Government had…equipped our people properly… and they had the right gear and had thought seriously. (*DEBORAH exits.*) One place to go under that bridge, right, a pontoon bridge, they couldn't get under it any other place. Surely…and they've been using it for years. Surely these people, these terrorists are gonna watch and know this is the place to get them. What has…what has gone wrong? Why hasn't someone stopped to think about it? They've got vehicles that withstand these bombs. Why aren't they using them?

ELIZABETH: No. I would have gone on the march. Not in my name, not in my name, there has to be other ways. Definitely. I'm a peace maker not a war maker. We don't have the right to take other people's lives. We don't have the right, I don't think, to interfere in other people. If people ask for help that's a different matter, if you put your hand out to me and say: 'Elizabeth I need your help', that's one thing, a country saying: 'Please help me' but as Deborah said before, just to what right do we think we have to, to walk in and…? We haven't, it's wrong.

ELSIE: And then you get the time when her boxes came, all her personal gear and I'm talking, I'm talking about boxes, I'm talking about…absolute seventeen of them. Saw them. A whole life.

Pause.

So I gradually did a little bit each day and sifted through it and got all of her clothes together, apart from a few that I wanted to keep, Her jewellery: I've not even…not even taken that out of the box yet; her jewellery box. Can't look at that.

ELIZABETH: I never assume that they'll be alright, from my side, I always ask the universe to protect them, and because I work as a healer I work with energy that can and does protect people. In my twenties I was diagnosed with multiple sclerosis. I became very ill just after I had the two of them which was very, very hard, particularly hard on Deborah I think, because she took over the role of mum as a child for a few years when I was so ill err… So I had to become very ill to learn that you are actually a healer, and of course the first person I healed, with the help of a dear old lady, was myself. So I've had multiple sclerosis for thirty years. I've been through an MRI scanner, my brain's very badly scarred, I shouldn't be here but I am.

You have an aura around you. Every living thing on this planet has a wonderful aura, that's the real you, okay? That aura can be strengthened by healing energy, and that's basically what my job is, strengthening the human aura. I mean I heal people, I do genuinely heal people.

But the children asked. Our son asked. Everybody comes to me, Elizabeth protect me, help to keep me safe.

Somebody once said to me there's black magic and there's white magic, you know because my friends sometimes call me 'The Nook of the North', the witch, right? Just jokingly. One of them actually bought me a broomstick, it's still out in the shed, it's great for leaves and I go flying on it once a month. Right, so we're talking about magic. I'm talking about black magic or white magic. Now there isn't, it's just all energy. It's how you want to use it.

ELSIE: If somebody starts talking to me about Sharon, em, I'll start changing the subject because I just feel I don't push it down their throats all the time and people will get

sick and they will get fed up and they say they won't but it's understandable. Em, but I try to put it so that the kids don't see me in such a bad state although I'm still sitting here wringing me hands (*She rubs her hands constantly.*) so I'll just stop doing that. Look at the state of me, all over me hands. (*Her hands are scarred from the rubbing.*) But that's em… I've sat on them and all sorts but they still creep out. (*She sits on her hands, but they creep out. She laughs.*)

ELIZABETH: As a child, hearing, hearing things that weren't there, seeing things that really weren't there, having invisible friends to play with, picking up erm, an injured bird, holding it in my hand for a while, feeling the heat in my hands and then the bird would fly away. Yeah.

ELSIE: The army welfare comes about once or twice a month… They sent someone in at first, em, because I wasn't sleeping, wasn't eating, wasn't doing anything really. All I was doing was em, drinking coffee during the day and in the evenings I was drinking vodka and coke and smoking about sixty fags a day. Might have been more, I don't know.

ELIZABETH: Well I *am* the mother, not the *kind* of mother, that always said to them: 'There's no such word as no.'

ELSIE: (*Sighs.*) I'm the kind of mother who feels strongly about her children.

ELIZABETH: It's 'I can', not 'I can't', 'I will', not 'I won't'.

ELSIE: I feel they deserve a good life and I'll protect them anyway I can.

ELIZABETH: When they've said: 'I can't do this mammy', 'Oh yes you can'.

ELSIE: And I just love them so much.

ELIZABETH: There's no such word as can't and that's what they were both brought up with.

ELSIE: I don't know what to make of this world and it makes you wonder whether it's worth bringing children into it, doesn't it? Really.

ELIZABETH: Positive, be positive but be kind and caring.

ELSIE: I don't know… I just feel – oh, I don't know. I really… I can't… (*Upset, she clears her throat.*) Em, she had a bright future really. She was thirty-four, did well in the job she did, and she was just gonna live in the sun.

ELIZABETH: (*Proud.*) Err he's a manager, he's got another job. He starts his new job on Monday; he's a manager in the MOD. And he'll never have to leave the country; he'll never have to work abroad again.

ELSIE moves to start unearthing buried framed photos. All the photos are blank. As she collects them she shows to audience.

ELSIE: If she saw these photographs round of her she'd go off it. She brought them round and she says: 'And don't put them on show!' (*Laughs a little. Indicating photo.*) That's Sharon when she was training, sitting on top of a helicopter.

ELIZABETH: I've got a picture of Anthony here actually. In his uniform. (*Finds photo.*) Ah he's err, a very handsome man. six ft three. And that's his wife god bless her and she, she's gorgeous as well. That's the two girls.

ELSIE: (*The two women stand next to each other.*) You know you said about Elizabeth? She's erm, a spiritual healer. Sharon used to believe, you know?

ELIZABETH: And that's why I say, when, when he got the phone call, when we got the phone call to say his friend had died; that Sharon had been killed, I'm a medium as well you know, I hear things, so I had picked Sharon up and at some point Anthony will go and tell her parents if he gets the chance. Right, we're feeling bad, what must it be like when you're there, thinking: 'My God that could…

there for the grace of God go I', you know? 'It could have been me.'

ELSIE: They sent a letter, erm, as soon as they had the details as to what had happened which is how I was able to tell you what had gone on on the boat.

They even described how she was sitting cos I wouldn't read it when they first…but I only read it the other night… and I couldn't (*Coughs.*).

But they said she was sitting, sitting up in an awkward position…very pale, erm, I think she would have been… (*Coughs.*) Ball bearings.

Ball bearings. In the head. (*She indicates the back of her own head.*)

I knew. I felt it on the day of the funeral. Loads of little (*Makes little shooting noises and indicates back of her head.*) on the back. I nearly fell off that chair. I just got up and ran.

The day of her funeral I was sat there. The kids were all in here and all of a sudden I just felt it on the back of my head. And I told the army officer, and he went: 'Are you psychic?' and I just went: 'I just know that's how she died'. And it was.

I just ran into the kitchen.

ELIZABETH: But he's home safe, thank the Lord, and the wonderful energy and he'll never, he'll never have to do it again.

ELSIE: Well, you know the old saying, don't you? 'A son's a son till he takes a wife. But a daughter's a daughter all her life.'

Music. The women except JANICE are sat. JANICE uncovers a bunch of flowers and hands them out to the others who begin trimming each bloom. This goes on while JANICE speaks. JANICE addresses the audience.

Titles: 'JANICE'.

JANICE: He was seven four (*7lb 4 ounces.*) born, twenty-one inches long. Took my labour in a school yard. He just had the most cheekiest little face you could ever think of, the way he would just giggle and laugh.

Michael loved his police uniform and his police helmet. Michael was seven, gone out with some of his friends with their parents and went down to Roker beach. All this time he was going to be a policeman. He picked some daffodils up, it was Mother's Day and he took them off the roundabout, and the next thing he knew was. He was absolutely mortified, because this policeman had brought him back home cos he'd stolen daffodils and Michael had actually said: 'But there was no gate on it mam and there was no house on it, so I didn't pinch them'.

He'd joined up with Carilion after leaving school: a painters and decorating company just off the Alexander Bridge. In November he said: 'I'm thinking about packing it in' and I said: 'No stick it out, Christmas is coming you'll want your coppers and you get so much on this scheme for, to keep you going cos you can't claim dole and stuff like that'.

JANICE begins to collect the flowers and arranges them in a vase.

And then it got to Christmas Eve and he said: 'Well mam, I've got the biggest surprise you could ever need', and I said: 'What's that?', and he said: 'I've packed me job in.' He said: 'So I have to say Merry Christmas', but he come down he'd bought us 'jamas, dressing gown, he'd spent every little bit of his wage of twenty-two quid. Just on me. He went: 'And here.' He had a bunch of these wooden

daffodils, there was five of 'em and he said: 'Yeah, that's for old time sake'. And I was like: 'First and only time been in trouble with the police', dya know what I mean?

And then he just said that em: 'The first thing I wanna do is, I'm gonna go, straight down the careers office and I'm gonna join up with the army', and I went: 'Yeah whatever'. It didn't matter where I went in the house Michael was behind us. Michael's pinny strings never got cut. Until this time. I think the boot was on the other foot then. It was me who didn't want him to go then. For all the years I'd been saying: 'God will you go out and play with your mates, will you go out and do something'. He didn't. He was a proper mammy's boy. And then come this time I'm like: 'What are you doin'? You can't be joining the army.' I'd been that used to him hanging round us for this long.

And the next thing I knew was he said: 'I've gotta go back for an interview' I said: 'Oh, lovely, what have you gotta do?' He said: 'I've gotta wait for the phone call to go for the proper interview' and I'm like: 'Oh champion'. He's: 'So, what will I wear do you think?' I said: 'Just stick your tracksuits on, you're just going as a civvy cos you're going in the army so you'll get a uniform, so it doesn't matter what you look like'.

So then after that it was erm, I sent him to this interview with his tracksuit on and you know how kids wear tracksuit bottoms tucked down the socks? I said: 'It won't make any difference, they won't take any notice of you, you're only going for an interview man'. Knowing for a fine fact he'd get his backside kicked. I mean it was me tryin' to sabotage him.

He went in proud as punch, thinking: 'Great, I'm gonna get in the army here'. This sergeant just took a look at him and said: 'Ok boyo, when did you turnout for an interview like that?' And he said: 'Me mam said', and he said: 'Your mam said, your mam said? You're a big boy now, gonna join the army and "*Your* mam said"?' He said: 'If your mam said go

run under that bus, would you go run under that bus?' He says: 'Get out and when you're old enough, without your mammy, come for an interview.'

Well. He come outside. He was absolutely furious. And he said: 'Mam, I need to do this…for me'. And then, I just looked in his little face his little eyes. He was very sad. And I said: 'OK. Come on then. *What* do you want to wear?' We went round the shop. I bought him the dress jacket he wanted, the shirt, the tie, the trousers, the shoes; he even got the underpants and socks to go with it. And he didn't even try them on. He came back home, he picked the house phone up, rang back to Borough Road and he was back on his way down there in within an hour.

And he come out and I've never seen a kid reach out as far as that kid did that day, he was absolutely ecstatic. He'd joined the army and he was like: 'Mam, I'm gonna have a life, I'm gonna have a career. I'll have money, I'll travel the world, I'll be able to do what I can.'

SCENE 4

Titles: 'JOANNE, JOANNE'.

JOANNE 1 and JOANNE 2 stand wearing sunglasses. They address the audience, talking at considerable pace, finishing each other's sentences etc.

JOANNE 2: Played the nick [JOANNE1: Yeh] (*Giggle.*) from school. (*Giggle.*)

JOANNE 1: Yeh, did all that. Did the whole sm[oking]…trying out smoking,

JOANNE 2: Drinking.

JOANNE 1: Trying out drinking. Saving dinner money up and going down Sunderland on a Friday night with the saved up dinner money all week starving ourselves everyday (*Giggle.*) at dinner. Us making pack lunches up out of the

41

house, so we could save up the dinner money to have a night out on a Friday night. (*Giggle.*)

Well it was previous to that we were both in relationships, we both… I mean we were only like nineteen, but we were both in relationships and the reason we went and booked the holiday was because we were really really miffed at our boyfriends for going and booking a holiday first with their mates. So we were like furious so we were like right: 'OK!'.

JOANNE 2: Cos apparently they'd said: 'Why. You's, you's are not going / abroad'.

JOANNE 1: Yeh yeh they, they just went and booked up with their mates with out even consulting us, so we were on like: 'Right OK if they can do it',

TOGETHER: 'We're gunna do it!'

JOANNE 1: So we, we went down the travel agents on a mission to go and book this holiday…erm just to see their faces when we got back basically and erm we…it was one of our friends who we went to school with who was booking the holiday and she was like well ya know there's this Kos one and there's this Crete one and we were like, err where do ya think? Looking at the brochures, totally undecided and then we decided / OK, we'll go for…

JOANNE 2: Kos didn't we?

JOANNE 1: We said Kos, [JOANNE 2: Yeah we did.] we'll go to Kos. Right so we rang back and we said we want to go to Kos, OK then. So as she was booking it, she was like erm: 'Oh sorry it's gone… / ya can't have…'

JOANNE 2: Or the price was totally… She said: 'I'm sorry I've mis-quoted ya. The price is like this now, instead of that', and we were like: 'Oh well, we're not / paying that.' So we said right we'll have the Crete one. So it was like…

TOGETHER: Totally

JOANNE 2: Gunna be meant to be really

JOANNE 1: Yeah.

JOANNE 2: The way it worked out. So we said: 'Right, we'll have the Crete one', and it was only a couple of months before wasn't / it.

JOANNE 1: Yeah ahum.

JOANNE 2: That we were going? Erm and we got out there and it was like allocated on arrival and our apartment / was…

JOANNE 1: We were gutted weren't / we?

JOANNE 2: God it was. / Awww…

JOANNE 1: It was like room only. Really basic, we were absolutely / gutted…

JOANNE 2: It was pretty…didn't even have any hot water did we?

JOANNE 1: Nah.

JOANNE 2: In this shower. Been there a couple er…a / couple of days and we'd gone out.

JOANNE 1: A Couple of days. Having freezing cold showers.

JOANNE 2: Yeah, gone out, quite a few nights and then this one day we were sat and them two had arrived hadn't they and they were in like the same / like…

JOANNE 1: The same block…

JOANNE 2: Their room was like opposite ours. And err, I dunno how we got talking to / them?

JOANNE 1: We came in and as I was closing the door I saw one of them peeping out the door, it was Tony peeping out the crack of the door and looking and I came in an' I said to you… 'They're spying on us over there 'n' like…ya know and to this day Tony'll go: 'No, no it was you spying on me', and I was like: 'No you were peeping out of the door on us', and then this particular night they came over and erm knocked on our door and they said: 'Oh we've

found this great restaurant that sells a lovely moussaka erm and it's right over looking the water.' And they said like: 'Would yas fancy going tonight for some?' And we were like: 'Alright then, but so far through this meal we were kind of giving each other that look as much as to say...

They look at each other.

JOANNE 2: 'Let's go.' (*Giggle.*)

JOANNE 1: Let's go, this is, this is crap. We, we wanna go out and we wanna go clubbing and stuff so we made an excuse...

JOANNE 2: That we had to go and phone our mams.

JOANNE 1: So erm later on that night once we'd got rid of them we ended up going to a erm a nightclub didn't we? Called, what was it? Scorpios or something?

JOANNE 2: Yes ahah it was.

JOANNE 1: Scorpios. And there they were, turned up in there. And we were like giving them the cold shoulder and stuff, we weren't really bothered and stuff like that and erm anyway, they ended up erm walking us home and stuff.

JOANNE 2: Ahah.

JOANNE 1: Back to the apartments. And then the next night we, we sort of said aw ya know: 'We'll not arrange to meet them, we'll not go out', but we thought aw they, they were all getting dressed up and and we thought: 'They'll go out and they'll bring some girls back', so we'd asked them if...

JOANNE 2: No...aye...they'd said their showers were hot,/ so we were like aw right yours is hot and ours are freezing...

JOANNE 1: They said their showers was hot. So we waited till they got ready and went out 'n' we said aw can we go in and get ready and use your shower? And they said yeah, yeah. So they give us their key and we went in their room and had a hot shower and that, and because they'd gone

out we said: 'Aw I bet they bring some girls back cos we'd give them the cold shoulder, we'll do their room up so that if any girls come back they'll be like – "What's going on in here?"' So we got some perfume and we, stuff from... 'Dewberry' from the Bodyshop and we sprayed it all over their beds and their pillows so it was stinking of girl's perfume erm...

They're both laughing.

JOANNE 2: Shaving foam all over.

JOANNE 1: And we put lipstick on the mirror, we wrote things with lipstick on the mirror and put shaving foam round so we thought if they walk in later with any girls, these girls are gunna be like... 'God, what's gone on in here with all this girly stuff around?' Then we went out and left them to it. They, they'd obviously gone back and they hadn't took anyone back with them, but seen the state of their rooms and come back out on the hunt for us to find us, hadn't they? They were like: 'What have ya done to our rooms?!'

Giggles.

JOANNE 1: So we hadn't like discussed like, aw which one do you fancy and which one do you? And this day when they turned up with these mopeds for some reason I just got on the back of Tony's bike and she got on the...

TOGETHER: Back a' Adam's.

JOANNE 1: And...like, we didn't know which one of them liked us or anything...it was just / like...

JOANNE 2: Weird.

JOANNE 1: Weird, how it happened. How I got on 'is, and she got on Adam's and like then, from then on, / obviously...

JOANNE 2: And they lied that they weren't in the army, didn't they? [JOANNE 1: (*Agrees.*) Uh huh.] They told us their names, this was the first day I think that they told us that

they worked in an office, but then eventually; cos they didn't believe that we were both called Joanne.

JOANNE 1: That's right, yeah.

JOANNE 2: They thought we were lying about our names because they were like: 'Yeah, you're both called Joanne. Yeah…we work in an office', and they / were like this…

JOANNE 1: Yeah…they thought we were lying to them.

JOANNE 2: I think eventually they told us they were in the army. Cos they were going out to Northern Ireland…

JOANNE 1: …at the time

JOANNE 2: Cos that was their holiday and when they come back they were going…a couple of weeks after they come back, they were going to Northern Ireland. And I think they thought…

JOANNE 1: They were gunna / die

JOANNE 2: They were gunna die out there because of the training they'd had. They…they must have worried them that much into thinking: ya know, it's a war zone.

SCENE 5

Titles: 'GEMMA, CAROL, JANE, SARAH'

The four women enter slowly and self consciously, gradually plucking up the courage to turn and face the audience.

SARAH: I'm married to John.

JANE: I'm married to Phil.

GEMMA: I'm married to James, I've been with him for eight years we've been married for seven, I met him when I used to work in the bar; the Naafi on camp. Um, we hated each other and now we're married with two children. (*They all Laugh. GEMMA encourages CAROL to speak.*)

46

CAROL: I'm married to Richard, we got together about eleven years ago and we've been married eight years.

JANE: I remember when I first knew my husband, one of my friends said to me: 'Has he killed anyone yet then?' And I was just absolutely stopped in my tracks and I thought: 'To that person that was an important issue'.

GEMMA: It's not even a question I'd ask.

JANE: I never asked it, because if I get down that road this is never going to go anywhere because where do you go from there?

GEMMA: I would think it would open a massive door then wouldn't it? You'd be thinking…

SARAH: Pandora's box wouldn't it, it'd be like where do you go from there?

GEMMA: No it's a question that I wouldn't even think about asking.

CAROL: No I don't think you would, would you?

GEMMA: You know Carol's husband's done twenty years and I've known Richard for quite a long time, but I can't imagine going up to him and goin': 'So, Richard in twenty years did you actually kill anyone?'

CAROL: No, you wouldn't ask and that. When Richard was only a young soldier he went to the Gulf War and we've got um…the *Sunday Times* followed it and we've got a book and Richard's in on the rocket launcher. You know it's weird to see that that's my husband stood on there, you know with…you can't actually see the faces, it's the outlines of them, the men, and I know quite a lot of them, you know? Who he was, first joined the army with and it's weird to see you know?

GEMMA: It is because I think there is a double, to a certain point it is a double life. We have our husbands and our family man and our best friend and etc. However we

don't really see; we see them in their kit, but we don't ever see them in their role as a soldier. So that part is kept completely away. So with what your friend's saying, you know, they expect us to know absolutely everything about what's going on in their life and we don't. We know very little, because: One: we're not interested.

All laugh.

CAROL: And I think sometimes you don't think about it, it's just now just standin' here you know, seein', thinking about the picture and talking about it, you know? What actual damage that rocket did, when it did fire. You know?

GEMMA: You can't think about that.

CAROL: I've just seen my husband on there and I'm proud of him. And you know we treasure this book cos we want to show it our likkle boy, you know? And our daughter and, it's like just sat 'ere thinking about what that damage could have done, when it fired. It's weird.

GEMMA: I think you've got to keep it separate.

CAROL: You don't really think about that. You know?

Pause.

GEMMA: No. No you don't.

Music. Fade to black.

END OF ACT ONE

Act Two

Titles: 'GEMMA, CAROL, JANE, SARAH'.

GEMMA: People don't realise outside what a difficult life we actually do lead.

CAROL: I didn't have a clue and I had the shock of me life when I was getting into it. How their life is really not their own. You know it's twenty-four hours, seven days a week.

GEMMA: As awful as it is when you know your husband's going away, you just want them to go, because when that time's ticking and you know your husband's going to… You know I've been really lucky. My husband hasn't been anywhere really bad for a couple of years now. Um, more or less had a holiday if you ask me. Cyprus? Mmm put your feet up, have a birra sun. Yeah I'll stay at home in Northumberland where it's freezin'.

Others giggle and agree.

How many of our children's behaviour goes through the roof when their dads are away, you know?

SARAH: And then when they come back…

GEMMA: Yeah and then when they come back cos they're not used to it and erm, as much as they're lovely dads etc, they still have this regimental way of going on, you know? He expects, once he says to our Amber to do something. And the amount of fights that we've had to say: 'She's not one of your soldiers. She isn't going to *do*, she isn't gonna jump to attention.'

He is so regimented in his life and he expects his home life to be that way and it's just not.

JANE: Especially when they've been away and they've been living away and they've been living by / that 24/7…(*To SARAH.*) Oh sorry.

GEMMA: It's complete chaos.

SARAH: Oh no… (*To audience.*) my husband's home in two weeks having spent six months away so, so this is all new to me. So we'll see how that goes.

GEMMA: It does take a bit of getting used to; sharing your bed again…

JANE: Mmmm, yeah I was thinking that actually, it's nice spreading out.

GEMMA: You know / instead of (*Exaggerates spreading out.*) waaay. You gotta (*Demonstrates being cramped in bed.*)

JANE: And them making a mess.

GEMMA: Yeah.

JANE: And they do.

GEMMA: Havin' a clean loo. (*Laughter. To audience.*) Please don't use that.

Another hat that we wear though? To help the mams as well. Not only are we wives and mothers, we're also the comforting voice cos we're the ones who are here. We become the comforting voice for the parents as well. God we're fantastic aren't we?!

JANE: We deserve medals ourselves.

GEMMA: I think so. (*GEMMA looks at CAROL who is about to speak, but then hesitates.*) Go on Carol.

CAROL: I'm the kind of mother who would like…to be like me own mother. Who's give everybody strength and always / been there for everybody else

SARAH: That's really nice.

CAROL: You know, I don't feel as if I could live up, live up to that. / How I see my mother.

SARAH: That's really nice, that's lovely.

CAROL: And she's just always been, she's a likkle lady. Em never wanted anything and just give everybody in our family, everything she could possibly…(*Upset.*)

GEMMA: But you do, but you do. You do. Just like all of us. Come on.

GEMMA reaches out and comforts CAROL.

CAROL: And at the moment she's poorly. (*She starts to cry.*)

GEMMA: And you do Carol.

CAROL: I would just be like, I would like to be like her.

GEMMA: You do. And you are. Because your mam brought you up and she showed you the right and the wrong and you do exactly the same as what your mam does.

JANE: Cos you're doing it every day.

CAROL: She'd help everybody, not just her…her family, anybody…she's…you know? And I think…I wish I could be like her.

GEMMA: But you are.

CAROL: Not like her Gemma.

GEMMA: Mmm.

CAROL: Sorry for cryin'.

GEMMA: No, It's quite alright.

CAROL: It's / just err…

GEMMA: It's quite alright, I think, I think yer right, when I think about my Mam. My Mam put completely everything on hold for us, and I used to resent her type of thing, and

she'd go: 'Well I give up my life for you', and I'd go: 'Well that's your own fault.'

But I've done exactly the same. So (*Beat.*) maybes we are more like our Mams than what we realise, but it's our Mams' nurturing and our Mams' strength that make us the people that we are today.

SCENE 2

Titles: 'JOANNE, JOANNE'.

JOANNE 2: We had a good laugh like.

JOANNE 1: We did, we had a good laugh and we were due to go home, and, because we had boyfriends

JOANNE 2: They wanted our phone numbers didn't they?

JOANNE 1: They wanted our phone numbers, they wanted to write to us and we were like…no, no, no. Anyway Tony was keep pesterin' me: 'Please let us write to ya when I'm in Ireland' and I'll be like: 'No, no ya not, I've got a boyfriend back home and stuff' and erm anyway she give in (*Pointing to JOANNE 2.*) and she gave Adam her number in the end and erm no sooner had we getten back, [JOANNE 2: They were on the phone.] they wanted us to go and meet them didn't they?

JOANNE 2: Uh huh. We did, we went down and / met them.

JOANNE 1: We went and met them for a weekend and / stuff and…

JOANNE 2: So we sets off on a Friday night…well you were still going out with Peter, I'd finished with my boyfriend but she was still going with her boyfriend.

JOANNE 1: I arranged an argument with my boyfriend so that we wouldn't be speaking over that weekend so that he wouldn't contact us.

JOANNE 2: So she could go away. But they'd booked a hotel for us to go 'n' stay in, which was nice wasn't it?

JOANNE 1: It was aye…but…we got there and we walked in the room and there was like a rose on the pillow wasn't there? On each of our pillows, and he went: 'Aw I thought we'd just have a night in tonight…we'll get a takeaway'. And there was like this rose on the pillow and a DVD so I was like: 'Aw great!' And she come in to the room (*Pointing to JOANNE 2.*) and was like: 'Aw what DVD have ya got?' And it was some bloody Sci-fi alien thing that Tony's like mad about, and I went: 'What have you got?' She went: '*Pretty Woman*' and I was like: 'How come they've got *Pretty Woman* and we've got like this sci-fi thing?', that he still loves to this day. Anything bloomin' *Star Wars* or *Star Trek* or anything like that he's right into. So that was like / the first…

JOANNE 2: But we did have a good weekend.

JOANNE 1: We did, we had a brilliant weekend after that. And then literally, after that, obviously they went to Ireland and Tony pestered and pestered the life out of me and eventually like, I broke up with this lad and he was like over the moon and I kinda said: 'Yes I'll be your girlfriend type of thing'.

JOANNE: And then they said at the end of the Ireland they were moving back to Catterick for five year, so it was kind of like: 'Aw well, ya know if they're coming back to Catterick for five year erm that's obviously gunna be the time when if like, if we are gunna make a, a go of it.'

Lived together for a year or so and we got married in '97… May '97…so…that was like ten year ago. (*Giggle.*) We're still here.

Title: 'JANICE'.

JANICE: Went down to watch him in June, erm for his passing out. When you see them there it's like: 'God that's not my

kid', they're actually men. But they're only kids underneath it. You know like, boys in mens' uniforms.

JOANNE 1: I go to Catterick a couple of days and cut the lads' hair and talking to them, I mean I had a guy in the other day, eighteen year-old lad he was and he's due to go to Afghanistan in, erm January.

JANICE: Took him down to the train station, he was like: 'Don't you dare cry, you better be strong.' He toddled off with these five, six, seven lads, lifted his head up, waved his hand, smiled and grinned, and I walked away broken-hearted.

JOANNE 1: I don't think they ever really thought that, when they joined the army that they would like ever go to like war, I don't think we thought about them ever having to go to like places like Iraq and Afghanistan.

JANICE: He was one of the first ones to volunteer to go to Basra. Signed up May 12th he was off May 23rd.

JOANNE 1: Our Jake said it the other day actually, he was watching that: *Commandos* programme that's started, he was like: 'Aw dad, I, I want to join the army.' He was like: 'Over my dead body son, no way'. He was / like…

JOANNE 2: I don't know, it would be awful, I would be devastated.

JANICE: He was only a boy, he wouldn't go there. He was a boy only training to be a soldier. He wouldn't be sent there. He would never get to war, he was too young. But it was a job he'd signed up to do, he'd wanted to do it, he was up for it.

JOANNE 1: I mean I said to that eighteen year-old lad the other day, I went erm, ya know I went: 'How, how does your parents feel about you going to Afghanistan in, in January, eighteen year-old?' Erm 'n' he went: 'Aw she's absolutely passed herself, she's worried sick'. I keep saying to Tony: 'Why do they send kids out there, why can't they say,

you've gotta be over twenty-one?' Cos there's so many eighteen year-olds been killed out there.

The two JOANNES exit.

JANICE: When he used to come home and we'd sit on a Friday night, he would say like 'Haway lads come and meet me mam'. And the army lads had said for it being a male domain, he used to speak quite open and quite frequently about his mam and how I used to be his little diamond he used to say. Erm she's not too big to get a slap, things like that, do you know what I mean, but he was quite a clown.

Titles: 'NIKKI'.

NIKKI: Sooo, av knocked about with him since a was, problys, bout eleven, eleven twelve, but never really tarked tur um, it's unbelievable innit?

One night I went tuh like a house party there, like everybody was just drinking un everything 'n' I just start talking to im and I think it was; You know the massive trampolines? Geet trampoline things, ineez back garden. Ah was play...ah was playing on that, un he was trying t' teach us how to do a backward flip 'n like a frontward flip yu know? It was starting t' get a bit dark 'n' that...just git lying on the trampoline tarking. He was telling us about the army 'n' when he went through training 'n everything, what it was like. 'n' his dad was in the army, his dad was in the army for twenty-five year, 'n' ee was in the err...what's it called? S something like SAS, something. Whatsit? I can't remember what its called the...ahh well, it's like the fittest in Britain 'n' all that's gotta go in. You've got to be like really well trained, RAF or somethink? Arh I dinnah.

JANICE: Sky News'd be on, News 24? That's the only thing apart, obviously when my granddaughter was in we'd have the Teletubbies on, but I've got a TV in the kitchen so I'd go and stick it on there. I'd go up to the bedroom and stick it on up there. Everywhere I went, it didn't matter where, you just...in one sense I lived in fear, in one sense I didn't.

Because he was…if he went out there he'd be in a heavy armoured vehicle, he wouldn't be shot at so he'd be safe, you know? He had body armour on. He was safe.

NIKKI: I'd just broke up with this lad so a was like trying t'stay away from um all night 'n' he'd seen us on the trampoline he was getting like geet jealous 'n' that 'n', so I just wahked out I'm not causing a big scene or anything. 'n' as ah was running up the street, a mean a nearly got home, Adam'd ran down, 'n' a was like, he walked uz home.

'n' then the next day he went back to the army, 'n'he kept on ringing uz, 'n' every night really, bur ah thought he was just, dinnah, he just wanted t' talk tur uz about the army, I had no idea he liked uz, that's how stupid I am.

JANICE: On Sunday em… I got a phone call. It was about a couple of minutes after twelve. It said: 'Jan put your telly on Channel 24'. 'En up on the top 'British soldier killed the rest were injured, one critical'.

So then it was like palpitations, I ran put the computer on. Logged on. Cos you get the crest up of the badge and you click into the badge. Then me husband says: 'There's two women comin' to your door'. I went: 'Two women?'

I thought well it's Sunday. And at that split… [second] I just lost all recognition of who I was, what day it was. Didn't know nothing, d'y'know what I mean? Just didn't know nothing. And she just kept on saying: 'Are you Janice Murray? Are you Janice Murr…?' Well I took off up the stairs. I think I was going for me coat and me shoes, I think that's what I was doing, but I don't know, and then I come back down and she says: 'Are you…?' and I says: 'Who are you?' Cos I never like…but it's like…who are they? What do they want?

(*Points to TV.*) And I'm like: 'Have you seen that?' And she just like looked. And I said: 'I'll be with you in two' cos I could not think what the hell was going on, but I said: 'Somebody's really going to have a nasty, nasty shock

today'. And she says: 'I'm here to tell you…that it's your son', and I'm like: 'Oh my God'.

JANICE crosses stage and sits.

They'd been on their patrol and they were on their way back, so they'd all nodded off and gone to sleep. And one of the other lads; erm he turned up at court for us cos he said he always respected Tenchy and he owed it to me to know the truth after the torment that I'd had from the army. He'd said em, that they were travelling back, they'd all gone to sleep, cos they were ten minutes from base. Em he says at that point he says: 'I woke up and the next thing I knew was; the trooper came to a halt. It stopped. It lifted us, It tilted us forward.' And he says, as they dropped back down, and they were in the heaviest armoured vehicle warrior trooper out there, as it went back down and Michael came forward and tossed everybody back on this side. Michael's helmet hit this lad in the chin, knocked him out. And the next thing they knew was everywhere was just thick black smoke.

And when he came to, he said: 'I pushed this body off me which I think I believe was Tenchy and thought; He felt dead'. And he just said he was…he felt the coldness and sweaty.

Pause.

As its come through the troop it's took his leg off, and Michael took the whole impact of the bomb, from his neck to every part of his body, just uns… ph, just breaks, bones shattered, down to livers, everything had been hit. Which was horrendous to sit at an inquest and hear.

NIKKI: 'n' then erm, the weekend after he was back, ah was going babysitting, me two little cousins. And…err, he rang us up 'n he said: 'Ahh what you doing tonight 'n that?' And ah went: 'Ah am babysitting', 'n' he went: 'Can a come?'. I was like: 'uh?!' I was like proper shocked 'n' ah went: 'Ar right then'. So he come over mine 'n' then we got picked

up, 'n' we went babysitting 'n' that. So, 'n' ah was, I think a was washing up 'n' he got loadsa bubbles 'n' scrubbed 'em in my face, gorr into a massive water fight in the kitchen cos the kids were in bed by then like.

All the floor, she's got laminate floor in 'er kitchen, was covered in water 'n' mascara down me face everything, proper mess 'n' 'e, 'e tried t' kiss us then 'n' ah wouldn't let um. An' he was like: 'Ahh wha', 'n' he, he went in like a bir of a huff. Then wi got the taxi t' the end of the street 'n' just walked down the street, 'n' like obviously first kiss 'n all that carry on, 'n then err went back t' Catterick the next day so…but, been going out with him since then really.

See, well a, I knew he would be going somewhere, but he says with it being his first time going over he would probablys go to a safer place.

JANICE: Let us get me book. (*She gets a large file.*) In a life of living in reality, I think I've become quite vulnerable. But to Michael's name I was very mentally alert. Cos I could log things down. Put things down.

JANICE starts going through the file. NIKKI continues with her next line as JANICE mumbles the following:

/ 21st. Card from family watched TV. Erm But from the 21st erm. From the 21st to the 24th only being three days' gap, there'd been everything sorted from funerals everything, in three days, so like, live life in the fast lane. And it seemed like months. And then I went down to Brize Norton and then this is when it all started on the 24th cos we were told upon the 25th that my son was intact and had a chest wound. Cos they felt And then they come on the 26th.

NIKKI: But then when I found out, cos he was supposed to be going to like, he could've went t'Cyprus or somewhere like that. Then when he turned round 'n' says: 'Ah I'm going t'Iraq'. I was like… (*Breathes out.*) Like cos I've seen it on the news 'n' that. He was like: 'Ah I'll not be going tur a

main place a'll probablys like, just go tur a little base or somewhere like that. 'n'e was going t'Basra – like one of the main places so a was like: 'Urgh!'

JANICE: I started asking questions because his left leg had dropped off; 27th his left arm had dropped off, by the 28th they weren't his, each time there was a knock at the door, each time, there was a knock each day.

I went through this agonising thing, havin' a child full impact of a bomb, being intact with a chest wound, and then arms and legs and everything starts dropping off. And then you find out on the day he's buried on February 2nd, you find out he's actually (*Demonstrates on her own body.*) from the waist up in half and one right arm and a face. It took from January till just a fortnight ago to actually identify my son. I'd been lied to all the way down the line. What they didn't do was come back, they didn't come back and tell me the truth when they later found out that there was… his feet was missing his leg was missing his arm was missing, things like that. And they kept going on; he was intact and saying: 'He was intact'. But then they told us they'd stitched them on, but they weren't even proved to be his. So I said: 'You'd better get them off if they're not his'. It just went on and on and on. It wasn't till October the 9th that I've actually seen my son; a photo. Inside the warrior trooper, with the extent of his injuries.

NIKKI: He come t' say bye tur is family 'n' everything he was like: 'Ah d' yu wanna drive down with me mam with uz t' Catterick?' and a was like: 'Ah don't know', an a was like crying hysterical 'n' that 'n' he was keep going tur uz: 'Don't cry, yu ugly when yu cry'. Trying t'make uz laugh, 'n' a was just, ah no good.

JANICE: I've sat everyday writing reports, going through statements, picking everything up. And it's like: what do you do? What do you do?

If I'm in I don't want to be in. If I go out, I don't want to be out. I get round the shops.

Em, and when I go out, yeah people just interested, people you know, they're all, everybody says it: 'How are you today?', and it's like: 'Oh I'm OK I'm fine'. And then it gets to the point like you go somewhere and people see you, still today, and they burst into tears. Or they come to you and they're giving you a hug. So, to go shopping is an actual nightmare for me because, the frightening, the most frightening part is everybody knows who you are. But you don't know who those are.

NIKKI: So a was just then driving down in the car. Ah it was really bad, a just knew if a turned round 'n' looked at him a would just cry my eyes out. Then yu had t' get out the car, 'n' say bye tur um whatever, like driving away and like watchin' um walk away. Ah it was just devastating. His mam was like, crying as well 'n' she was going like: 'I'm gonna get in and drink a bottle of vodka your welcome to join us'.

JANICE: You're just so lost, it's like: What do I do? Do I…? I mean I've still got two huge boxes upstairs. Right across them it's got: 'The last effects of Private Michael Tench', and his number on it. I've still got them to empty. It's like, do you go in them? When's the right time to do that, how do you get round that?

When he played football Liverpool and Man U [nited] wanted to pick him up. He was a kid of eleven; kids of eleven can't make their mind up with a choice like that. And I said: 'It's a short-lived career son it'll only last eighteen month. It'll only last eighteen month in football. If you're going to do something then join the army. At least you've got a career and a life ahead of you'. And then came the guilt trip cos he lasted eighteen month. So I was made to eat me words thinking football'd want him for eighteen months and he only had eighteen month in the army. Eighteen month.

He'd probably tell us to shut me mouth. He'll have probably said: 'I've done what I had to do', and he, I

mean on his last phone call he did say to us: 'If I don't come back mam, be strong, don't cry, just think I was doing the job I wanted to do'. Cos he said: 'I haven't left you, and I'll watch over you'. I said: 'Don't talk wet, are you stupid?' But he would laugh and he would giggle. You know there are a lot of things that he said in his last couple of phone calls. What I found most strange was that last week, he rang every God-damned family member. Michael would never ever phone every member. But on that day he phoned me back twice, and I actually thought something was up. I thought 'ah it's just me, just a mother.' It was strange, as if he'd had a premonition. That he wasn't coming back.

NIKKI: It was like our year's anniversary. 'n' he rang uz, 'n he was like: 'Ah, git ah happy anniversary' all that carry on, he was git like: 'What you doing?' 'n' he was like: 'Eee what would yu do if a was in the country now?' 'n'a went: 'Ah dunno ad probably scream', just like joking, 'n' he went: 'Well I am, and am on me way t'pick you up now'.

JANICE: Like I dunno; wonder what he'd look like now, I wonder if he'd be coming home yet. All these things. I mean many a night I used to lie in bed waiting for him to run across the top of the landing, four, five o' clock in the morning. I mean you know it's not going to happen.

But everything that he said that he wanted and everything that he would like to do…that's why we're sitting on this three-piece now because that's the one that he picked. Everything that's going on in his last phone call, we've took as his last request, and that's what we did. That's why we've ended up with two dogs as well. Cos he said he'd have two bulldogs, so, Jan got two British bulldogs. But it's ya know, it's not, I mean yes he's everywhere, err it doesn't matter where you go and it's like, as I say we raise money for the charity for the neo-natal unit but that's to buy an incubator which is £16,000.

As you can see he's still right round the house. Em But we've got him on cups, we got him on pens, he's on key rings. He's just everywhere. I mean as I say we do charity dos and that. And we've all got these t-shirts with his face on the front.

NIKKI: So I was just sitting there like in me pyjamas, me hair a mess 'n' everything, 'n' he was like: 'Ah am coming to pick yur up now', so I like put the phone down then a was thinking, is he joking? Right, ran upstairs 'n' got me self all ready 'n' that, but he, he said tur us, on the phone, that he'd been injured. So I was like… 'God, what's happened?' (*Short pause.*) 'n' then err, so, 'n' he come in, his face was all swollen. (*Beat.*) He got bit. By somethink on the plane, (*Laughs.*) Like on the plane coming back? How unlucky is that? Fell asleep, he woke up on the plane, his face was just massive.

JANICE: Well I mean, I mean truthfully because I am that kind of mother who does protect, which mother doesn't protect. I'm just a mother like any other parent, who loves their kids who would protect their kids. It's very sadly and tragically that I've been a million mile away and couldn't protect my kid, couldn't help him. You know the only thing I've got left now to do is taking flowers and that's hard.

NIKKI: Well, next time's gonna be worse I think. Next year he's going t'Afghanistan, which is supposed t' be worse than Iraq. 'n' he's going over Christmas so like, next Christmas he's gonna be away all over that. Just, a dunno how long a can stand it!

JANICE moves from the stage to the auditorium as house lights come up and stage lights go down. She delivers the following through a microphone.

JANICE: All I got in the inquest was em how they apologised, just profusely apologised, apology after apology. I didn't want any more apologies then do you know what I mean? I'd had enough. This is a kid's life they were talking about.

But now the army have to change their death policies and procedures, which I was pleased about, very pleased about. Cos no family should have to suffer ten month.

There's a lot of unanswered questions, because I've got his boots in me back garden, because he didn't have legs otherwise the boots would have went with him. But the pictures I'd seen my kid did have one right leg.

The army tried to have it behind closed doors, but I wouldn't have it. I mean… I…honestly if they had told me truthfully, I mean anybody can make a mistake, we're all human at the end of the day. You know? But if it'd been one of us messing around with somebody's life we'd have been in Newcastle Court now standing trial.

I come out of me inquest and it's still going on. Another IED bomb had gone up and killed lives. If my son was in the most heaviest protected army vehicle, why is he dead?

I loaned my son to them to do a job, I didn't say you could keep him.

Cos all eighteen year-old lads are very eager. If I said to an eighteen year-old lad I'll give you 500 quid and your month's wages to go out there, how many of them wouldn't at eighteen?

But for crying out loud, pull them out. You know, there's too many lives lost.

You know, people who have been killed 2005 are still waiting for inquests to come forward.

It's not so much the army, it's the higher ranking officials, you now there's a lot of people out there put pen to paper, a lot of people can call the shots, but at the end of the day it's like I said: 'For Christ's sake put your pens down, get out there and see what it's like. Come and meet us families. Come and see exactly what we feel, come and see exactly what we do with our lives now.' Mine's totally stolen.

JANICE offers the microphone to members of the audience. If someone wishes to speak she lets them. She then exits the theatre through the auditorium.

Silence.

SCENE 3

A member of the company sets a dictaphone on a chair and presses play. MAGGIE's interview plays. MAGGIE walks towards it, picks it up, listens and after a few lines joins in. The actor's voice exactly matches the recording. After a few more lines the actor silences the dictaphone.

Titles: 'MAGGIE'.

MAGGIE:...Erm, but, er. I loved...I didn't realise how much I would love being a mother. I thought, because I'm not very maternal anyway. And I'm not, even now, little...tiny babies, I'm terrible with. I'm not one to 'coo' over a baby ever. I'm, erm, I'm more liable to just think, well, when they're a bit walking, or talking, or...stop being sick.

1982, I had Stacey. The whole time I was pregnant, I used to think, oh, will I cope? Will I be able to do this, cos I know how useless I am. I know how, how like un-maternal I've been all me life. But I think, once I had her, I just thought, this is gonna be a doddle. I knew I could do it.

Even though I was with his dad I never had much to do with Craig as a lad, he was quite a shy boy. You know, and he had his real mam and that.

Craig would've been, have been, eighteen probably by the time he actually passed out, you know, into the actual army.

Well he's not the best one for keeping in touch. I remember Ken used to hate the news at six o'clock. He used to worry that nobody would get in touch with him. Because, officially, his mother was, erm, the next of kin. And she might not tell him.

Well we'd seen on the news it had said that there'd been some fusiliers killed and injured in a road attack in Basra. Well, we knew he was in Basra so that started ringing bells straight away. And it turned out...it was Craig's armoured car what was hit.

The road bomb had come through the van and had damaged Craig's leg. His leg was quite badly injured and err but everything seemed to be going alright sort of thing, but then the phone rang and it was Craig sayin' they were actually going to amputate his leg. There was no muscle left and you know there was hardly anything there. You know his bones were shattered and everything.

And then it got to err Christmas and they said err he could come home, for Christmas. When he was away in the army his mother had moved to a small flat miles away. Ken says: 'well you'll have to come stay with us'. I was going to make the dining room into a bedroom and I had spoke to Craig and had said: 'What do you wanna do?' And he had said you know he would go up the stairs on his bum you know? He didn't want to make any fuss.

Err we had a nice Christmas and then they phoned. They must have rung up about something and he must have said that he was quite settled at home and could they not transfer his care up here and they said well yes if he was prepared to stay. He stayed, he didn't go back and err that was two years ago.

Yes, ah yes, totally different now, totally different, totally different relationship. I think he's mine now, I think I'm his mam. (*Laughs.*) I remember once he was on the phone to somebody he says: 'Ah no, I'm not staying out all night I'm coming home'. I thought: 'Ah, he thinks this is home' and I remember thinking: 'He's me son' and like little things now you know? He'll say things like err, if I've done something like his washing or made him his tea he'll go: 'You're the best mam', you know and I think I'm his mam now. I don't think of me as anything other than his mam and it's strange

that I feel like that way now because I've known him all them years and I never thought of as his mother.

I was worried when he first came home, because he had shrapnel wounds as well in his back and as I've said before, I can't even change a nappy, so me? Dressing a wound? No! And err, and I'll says now I don't know how I used to do that. Because I used to dress his wounds for him on his back and you used to have to like wash it and put some stuff on, and clean it and then put some more of these pad things on. And I just did it because I didn't want him to be in any pain or discomfort. And they'll, say like now: 'How did you do that?', I'll say I just don't know how I did it. I just did it and I never even give it a thought.

And when he's come home. When we found out he could stay. I was over the moon to be quite honest.

MAGGIE presses play on the dictaphone and leaves it on the seat. Another member of the company picks it up.

SCENE 4

PAT enters the auditorium carrying a glass of cider and smoking a cigarette. She chats to people on her way to the stage. The Dictaphone is silenced as PAT begins speaking.

Titles: 'PAT, MARIA'.

PAT: We were always together. We never very rarely went anywhere without the whole family. Cos we lived in the country. We're living in erm Bordon, just outside of Petersfield? And of course, they've got all the [Shooting] ranges and they used to love going in, pretending they're the Army, specially when the Army wasn't working on the ranges. We used to go over there, Byron and Paul, and the dogs…and they used to erm take their guns with them, you know tha' toy guns, and they used to chase around and used to find all the, the live bullets that the army had left. And they used to get their dad to take all the powder out

66

and put it along the wall and their dad would set it off and it'd (*Makes whooshing sound.*) straight across the wall.

You're not supposed to keep the live bullets, but erm. It was just – we were a family. I mean, you don't, nowadays. It's not often you see a family like what we were. *We* did everything together. (*Thinking of the answer to a question.*) Erm.

MARIA: A soldier. (*PAT moves to climb on stage.*)

PAT: The soldier yeah.

MARIA: A cuddly / toy.

PAT: A cuddly toy. It was a knitted / one.

MARIA: Grandma / knitted it. (*To the audience.*) You know them wooden toy soldiers? With the red and the… Yeah, it's like the old wooden soldiers, / so…

PAT: Red and white. It had brown feet, brown hands, red and white / coat . .

MARIA: …and blue trousers, navy blue trousers.

PAT: (*Agrees.*) Uh-huh blue trousers and it had a blue hat on. Like a soldier I would say it was. Cos he always used to be mad. He used to play soldiers, (*To MARIA.*) didn't he? All the time he played soldiers. Erm, and he lost it when we were in erm Blackmoor. [MARIA: *Yeah.*] he lost it and ee, that teddy went everywhere, everywhere with him. Went to bed with him as well, and by the end I think it was threadbare but he cried his eyes out when he lost that. Erm, I think that was about the only…oh and erm, cardboard boxes. He used to make forts out of cardboard boxes. Cos I got a hamper one Christmas and it went into a castle. And both Byron and Paul, they weren't interested in their presents, they just wanted to play with this castle. How they got the two of them inside it I don't know. And also erm Paul was an altar boy when he was younger. [MARIA: He looks so sweet and innocent if they

only knew.] … He was erm, he was a very quiet boy. [MARIA: He was, yeah.] Very quiet. He wasn't cheeky. He wasn't a cheeky lad, like Byron. Erm. He had the grin. [MARIA: Definitely.] But he was just… ah he was just a son to be proud of.

But he was the type of person, it doesn't matter who was in the room. If someone was sitting in the room and had a miserable face, as soon as he walked through the door; within seconds, [MARIA: He'd do something.] he'd do something to make them laugh you know?

And at Christmas time. Cooking the sausage rolls…ahh he would hide around the corner, cos I'd say to him: 'Right leave them they're cooling'. And he would sneak into the kitchen and not just take one, he'd take two big handfuls of the sausage…well he didn't know that they'd just come straight out the oven, (*Laughing she raises her fingers as though she's just burned them.*) and he didn't know, and I started chasin' him with a spatula, well it was a thing every Christmas then: 'Oh me mam's cooking the sausage rolls' and he used to say: 'I'm coming to get them' and I'd say: 'No you're not, you leave them alone they're for Christmas.

(*Enjoying the stories.*) He came in and he had all like his uniform. (*To MARIA.*) You remember this? And he had the penknife right? (*Laughs.*) And he was playing around with the penknife and he was going: 'Eee look how sharp this is?' And I was going: 'Put it back. It shouldn't be used'. And he says: 'It's alright, it's safe'. We had to take him to the hospital. He cut the top off his finger. Almost took it completely off right. He clicked it, and he forgot to remove his finger in time, never let him forget that. Every time he picked a knife up: 'Put that down!' (*Laughing.*) 'Do as you're told, put it down'.

Well, they weren't allowed to say too much. Like, you know, all we knew was he was going out to Iraq, we didn't know exactly where he was going. One day he said to me,

he used to ring up about once a week, wasn't it? Once a fortnight. He said: 'Oh mam!', he loved his hamburgers didn't he, loved his burgers, he went: 'I'm gonna have a burger soon'. Well we heard on the television that they were building like a McDonalds or something in one of the palaces, so we just sort of had to put two and two together.

A member of the company offers PAT a microphone and insists she takes it. Although confused, PAT eventually takes the microphone and speaks into it. She finds these recollections upsetting. She lights a cigarette.

Been out for the day with me mam. Been to Cullercoats and we're talking about him coming home, having his birthday party. Took me mam home. She was in a wheelchair so I had to take her home. And I came over home on the ferry. Am sitting on the bus and we'd just got to about the Nook and me phone rang. And it was me daughter in law and she just asked me if I'd heard from the Army. And I just said, are you trying to tell me my boy's dead? And he was killed at the time I was sitting with me mam, talking about his birthday. And they were all ambushed in the police station. I know now that Paul was the last one to be shot. He saw his five friends killed first and then, Paul was shot twice in the head, three in the neck and four in the chest. But I was told he died instantly. I'm still haven't getting over it now and that's four years ago. I didn't find out straight away cos I wasn't the next of kin, which is what we're fighting for now. Is that not just the next of kin finds out. The parents get to know at the same time as well. Because as I said to the Army, not just he died that day. Part of me died. Cos I carried him for nine month. I just can't believe I'm not going to see him again.

A member of the company retrieves the microphone. PAT recovers herself.

I think it was on the 22nd, there was some of the soldiers erm went in searching the houses. And they had the dogs. Well it's against Islamic rule to have a dog in the houses.

And of course they started stone throwing that day and there was a, a platoon that were up on top of the police station, and they were firing above their heads. Someone said: 'Al Majar al-Kabir' what's erm…what's the word for it Maria?

MARIA: Hostile.

PAT: It's a hostile…is that where there's war?

MARIA: Well, yeah, it's a hostile village where there's er, trouble / going on.

PAT: Where there's trouble?

MARIA: Yes

PAT: It's not a benign place. [MARIA: It's definitely hostile.] It's a no go. Well, however they put down in their booklets that it's a benign place. Course they sent the six lads out there on the 24th. It was Simon Hamilton-Jewell, Russ Aston, and I think, North Allerton, it was erm Ben, Ben Hyde in the room with the Iraqi police when they heard this commotion and there was an ambush of people coming up. And of course they went straight for the police. They must have said, you know, there's soldiers in the police station. And erm, [MARIA: So it was basically four hundred against six.] that's 400 against six. Iraqis. Yeah it was a mob. We don't know whether it was the trouble that started a couple of days before

MARIA: You know when the Paras were / in.

PAT: This is what we've heard from the statements, the Iraqi statements from the inquest. Paul was hunched up against a wall. Simon H-J. went over and put his arm around one of the soldiers which they identified as Paul. And they said he was shaking. And erm, and then they had to run into the police station. I know one of the lads was shot outside, I think it was Simon Miller, was shot outside. And there was a hand mark of his blood on the wall.

And then, they just went in and shot them one after another. Paul was the last one to be shot.

Well, actually erm, he wanted to join the Metropolitan Police and it was me that actually said to him: 'Don't you think it's a bit dangerous on the roads? Why don't you join the RMP?' (*Sobs.*) I'll never forgive meself. [MARIA: You weren't to know mum.] I thought he would be safer in the army as a policeman. And when he came out of the army, he always said when he come out he was gonna join the Metropolitan Police. Now, you know I mean, you can't, you can't turn back the clock. I sometimes wish I could.

PAT recovers herself.

You know I did a charity night a couple of years ago at the Cleadon Club and we raised over a thousand pounds for a bench and a flower va[r]se, a flower / va[y]se.

MARIA: Yeah, you know, them marble / ones?

PAT: A marble vase. It's down on the seafront. You know where…? (*To member of the audience.*) Do you know South Shields? You know where Mango's Bar is? It's the Water's Edge, used to be the Water's Edge pub? Well it's on that road down to the Water's Edge pub. It's actually leading down and when you're sat on the bench, there's the cannon where they played when they used to come when we first moved up here we'd go to South Shields and we used to walk along the sea, they loved South Shields. And the cannon is where him (*Points to Byron.*) and our Paul used to go their bikes and ride around the cannon and go and sit on the cannon and that. It's a funny thing to say but I feel closer to Paul when I'm sat on the bench. We had the bench blessed. We had a proper ceremony. We had the Lord Mayor, the ex- like the Deputy Mayor, and the Mayor from the year before, and David Milliband went. Erm. And we just had a fantastic time that day, it was lovely. I've got all the videos of it. Erm.

I know there was a, a lady on the bus. Erm, I know when the phone rang. What I said to Gemma. 'Are you trying to tell me my son's dead?' And I turned round on the bus and I can remember saying: 'My boy's dead. My boy's dead.' And somebody took the phone off us erm, and she said, she asked who it was and she says: 'D'you realise this lady's on the bus on her own?' And the bus driver stopped at the bottom of the street and this lady got off and brought us up home. There's nobody in the house and it was seven o'clock before I saw an army officer walking down the street. And I asked him afterwards, I says: 'Jeff be honest with me now. If my neighbour hadn't of rang Colchester to ask if it was right that my son was dead, how would I have found out?' He says: 'Off the telly' cos I wasn't the next of kin. Which is what we're fighting for now. Is that not just the next of kin finds out. The parents get to know at the same time as well.

He was in the army four year before he was killed. He was twenty-four when he was killed. It was his first place out of the country.

PAT and MARIA are joined by the other two actresses. The following exchanges are heated and impassioned and as the scene progresses the lines begin to overlap.

PAT: The war. I don't think it should have been started anyway. It wasn't our war.

JANICE: It was an American war.

ELSIE: The way I look at it there was lots of women and kids and men and boys just getting slaughtered and you can't stand by and let that sort of thing happen without having some sort of input.

MARIA: There was no weapons of mass destruction.

PAT: Well there was. There was two. Bush and Blair.

MARIA: Well, why d'you think they hit the oil tanks first? They blew the oil tanks up.

PAT: Blair was licking Bush's arse. (*To audience.*) Excuse me, sorry. I mean, I hate seeing the bloke on the telly. As far as I'm concerned, there's blood on Tony Blair's hands. Blood on Bush's hands. I'd never shake Tony Blair's hand.

ELSIE: I think at the time, when it all kicked off, and I think the reasons at the time were right for us to go in.

PAT: Erm, if you're fighting for something for your country, yeah. But it wasn't our country. It was their country. Somebody else's country. Would they help us? If we went to war, would they come over and help us?

JANICE: If I said to an eighteen year-old lad I'll give you 500 quid and your month's wages to go out there, how many of them wouldn't at eighteen.

But for crying out loud, pull them out. You know, there's too many lives lost.

PAT: I mean, in this day and age you don't expect… Yeah, join the army, make a man of you. But you don't expect them to go to war. D'you know what I mean? They're here to protect us, our country. / It was nothing to do with our country. It was America.

MARIA: Anybody in the army, mam. If they get told they're …

PAT: Yeah I know but in this day and age you don't expect it. You know what I mean? If it was like, World War One and / World War Two.

MARIA: Yeah but, that's the army mum. Anyone in the / army …

JANICE: I mean there is a lot of innocent bystanders you know, I mean people's hearts being ripped, people's lives are being torn and shredded, their houses, you know even down to a bomb explosion on a bus.

PAT: I couldn't say I hate the Iraqis. I can't say that. I don't. I don't hate the Iraqis.

ELSIE: We're not standing laughing at them getting killed. But they're laughing at us /getting killed.

PAT: Meself I blame the Army. Because when his platoon did come home they brought most of the ammunition. They took the morphine off them, they had no morphine. The lads didn't have any morphine in the police station.

ELSIE: If our government had equipped our people properly, one place to go under that bridge. Surely these terrorists are gonna watch now and know this is the place to get them.

Music. One by one the WOMEN focus on something out beyond the audience.

WOMAN ONE: There's a book. There's a book and Richard's in on the rocket launcher.

WOMAN TWO: (*WOMAN TWO follows WOMAN ONE's gaze.*) You can't actually see their faces.

WOMAN THREE: (*WOMAN THREE follows.*) They all look the same.

WOMAN TWO: It's the outlines of them. The men.

WOMAN FOUR: Kept completely away.

WOMAN ONE: Thinking about what damage that rocket did when it did fire.

WOMAN TWO: A lot of innocent bystanders.

WOMAN FOUR: You can't think about that.

WOMAN THREE: Pandora's box.

Loud door-buzzer is heard. Music builds.

ALL: I've got a picture!

All the women scatter and start scrabbling on the floor, uncovering blank photo frames, and the personal belongings of their children, until the stage is littered.

Images,which run till the end of the play are projected: the interiors of the women's homes, photos on their mantelpieces, videos of passing out parades, politicians, angry mobs, military aircraft etc. This is accompanied by pounding music, almost a chant. The women, desperate, try to be heard over the noise.

ELIZABETH: I've got a picture of Anthony here actually. In his uniform. Ah he's err, a very handsome man. 6 ft 3.

The following builds in pace with lines gradually overlapping.

PAT: This is Paul in Iraq in front of a Land Rover.

ELSIE: That's Sharon when she was training, sitting on top of a helicopter.

JANICE: The first picture is what you see as a young boy. Very young boy. His passing out in June. And then six weeks after you've gone from a boy to a man.

ELSIE: Well that was presented to Sharon from the Sergeants' Mess. The Intelligence Corps. From one of her postings. Rapid Reaction Corps. And they're her medals.

JANICE: Every drawer underneath here is everything to do with Michael. And pictures, to newspaper clippings, Michael's everywhere he's everywhere in this whole house.

PAT: It's just a letter to us telling us that he's gone to heaven.

JANICE: Michael in Iraq sitting under a tree, Michael as a civilian. When he was home on his last leave. Michael was the youngest British soldier to be killed.

ELSIE: There's Gary, on this side, when he was in the Guards and there's Wayne who's in the Artillery now, the young one.

Sound of approaching helicopter builds, drowning out the music and women's voices.

JANICE: That's the medal to say he'd been in Iraq. It's got a Queen's crown on it. It's just Iraq his number and his name inside a little green case. Nothing to say he's been killed.

JANICE notices the soldiers in the film projected onto the US wall. She moves to the wall touching the faces of the soldiers. Gradually the images are noticed by the other women.

The WOMEN can no longer be heard. Exhausted, the WOMEN just face the wall watching the images. They all watch the projections. The helicopter gives way to music and the final image: a view through a net curtained window of a tree in December. The curtain moves gently in a breeze. Blackout. End.

www.ingramcontent.com/pod-product-compliance
Ingram Content Group UK Ltd.
Pitfield, Milton Keynes, MK11 3LW, UK
UKHW020739280225
455688UK00013B/747